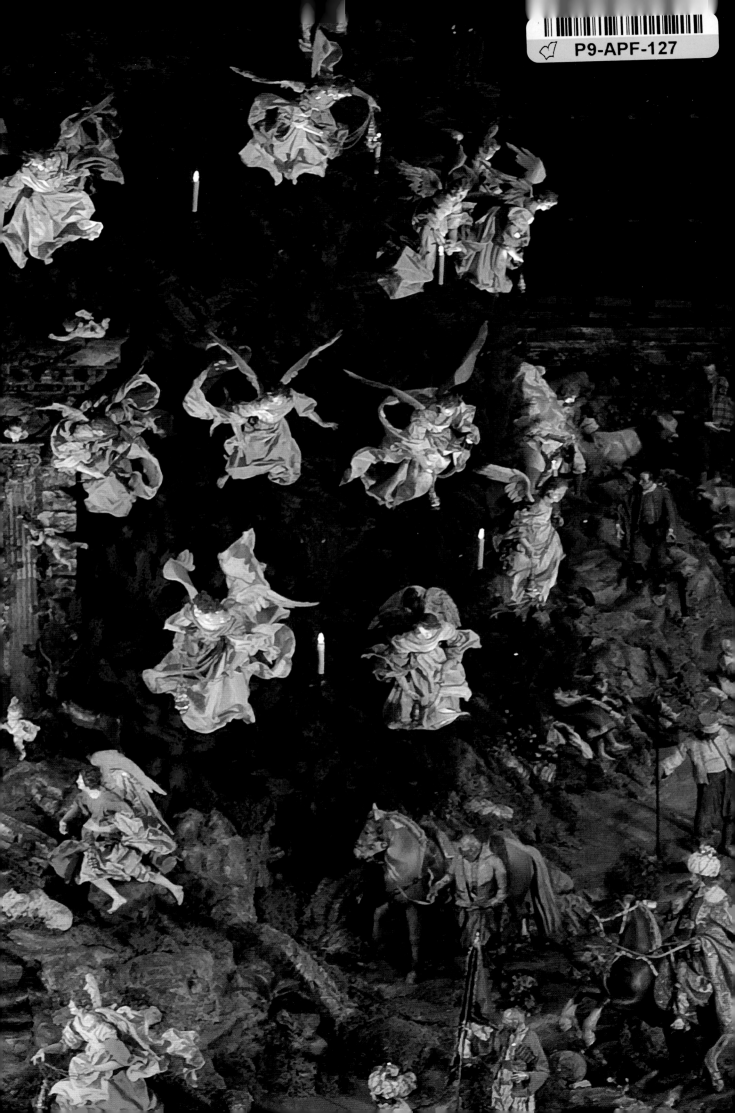

The
ANGEL TREE

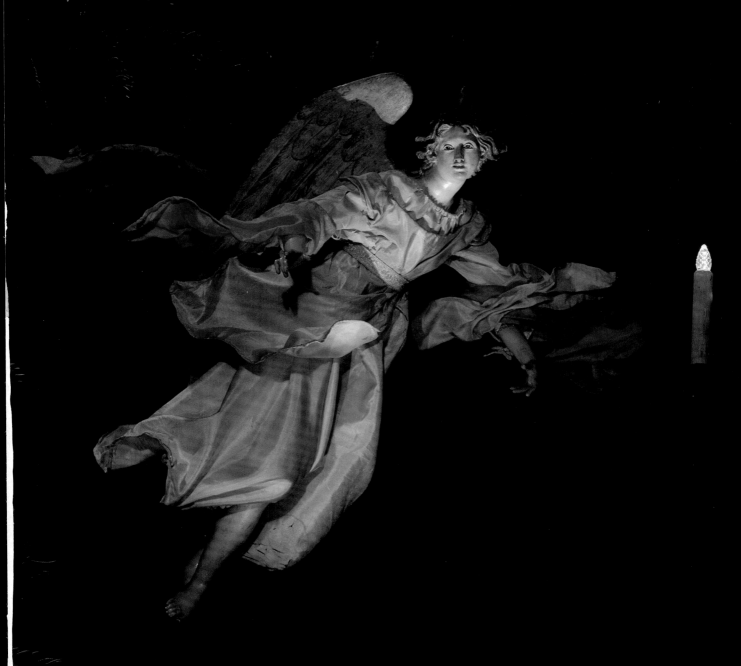

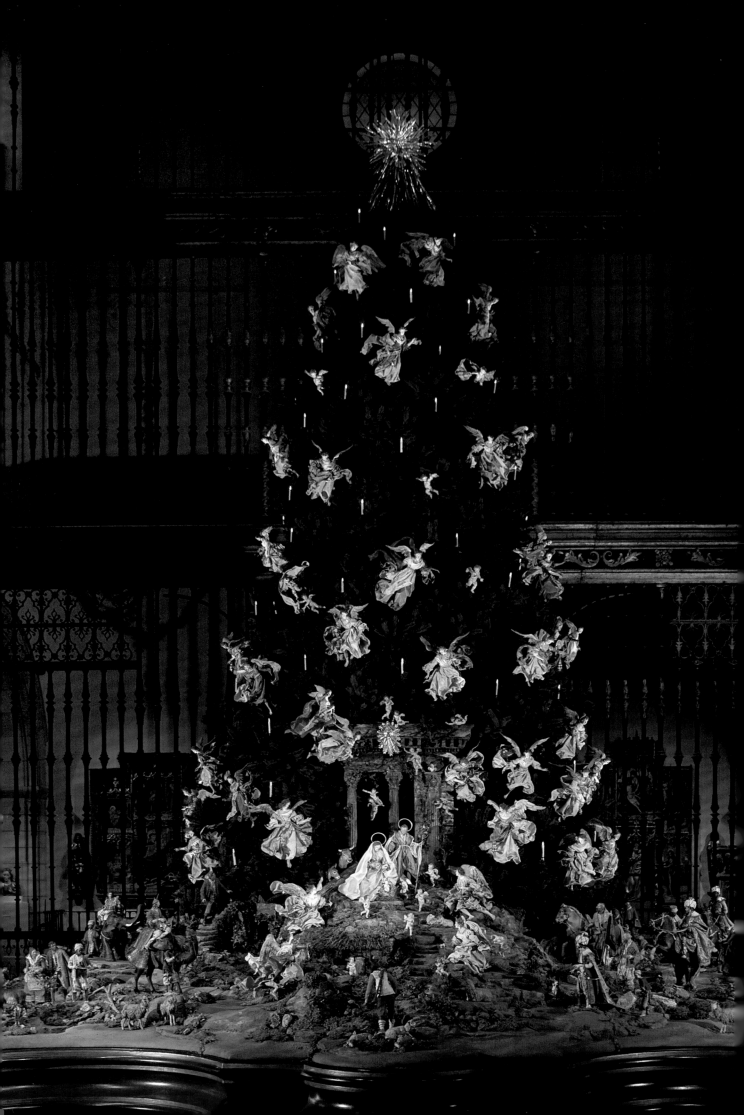

The ANGEL TREE

CELEBRATING CHRISTMAS
at
THE METROPOLITAN MUSEUM OF ART

THE LORETTA HINES HOWARD
COLLECTION OF
EIGHTEENTH-CENTURY
NEAPOLITAN CRÈCHE FIGURES

text by
LINN HOWARD
and
MARY JANE POOL
photographs by
ELLIOTT ERWITT

ABRAMS, NEW YORK

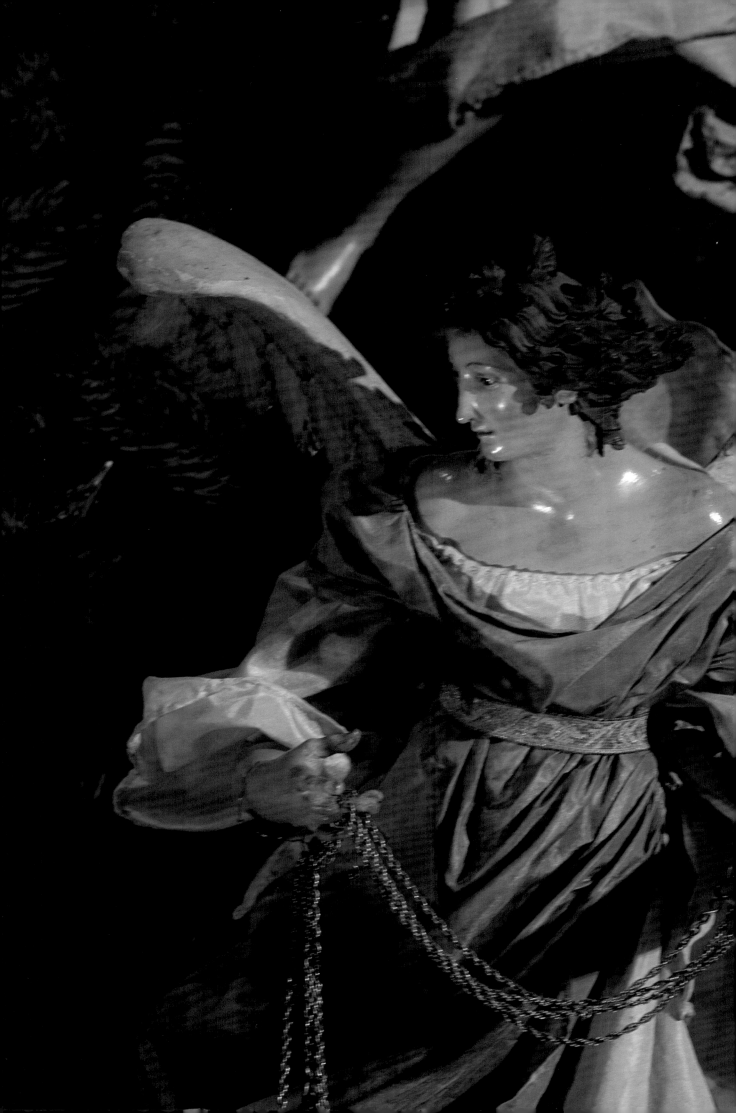

for
LORETTA HINES HOWARD
AND ALL WHO HAVE HELPED CREATE THE
ANGEL TREE
THROUGHOUT THE YEARS

CONTENTS

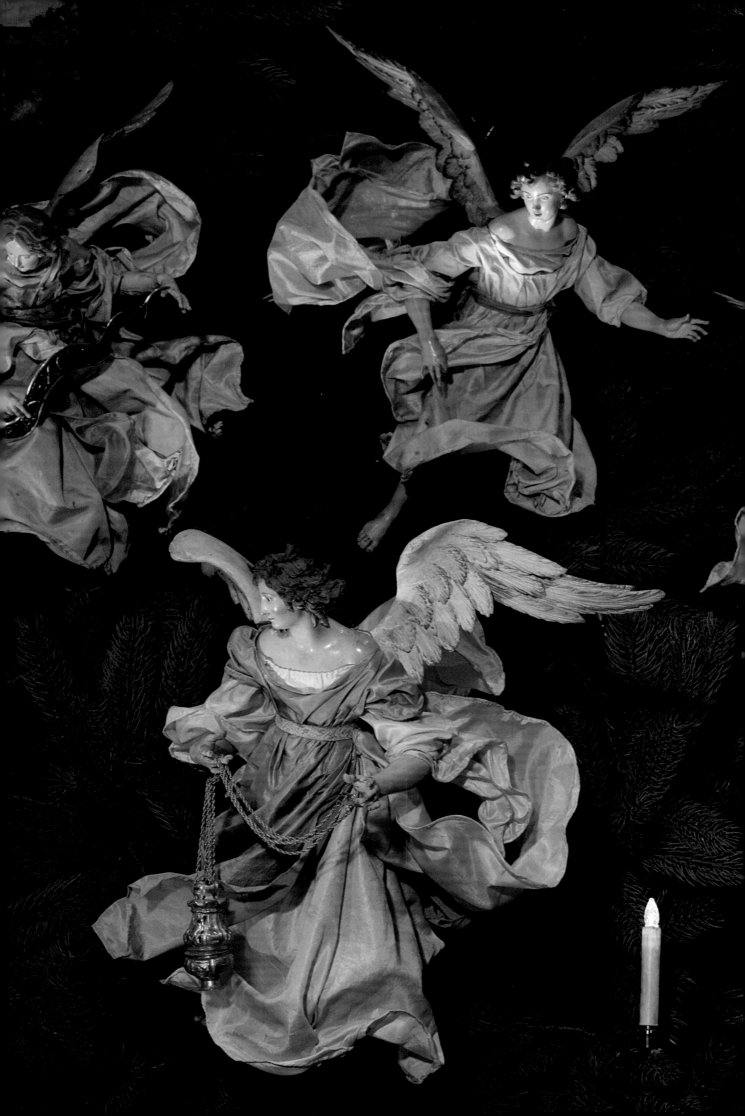

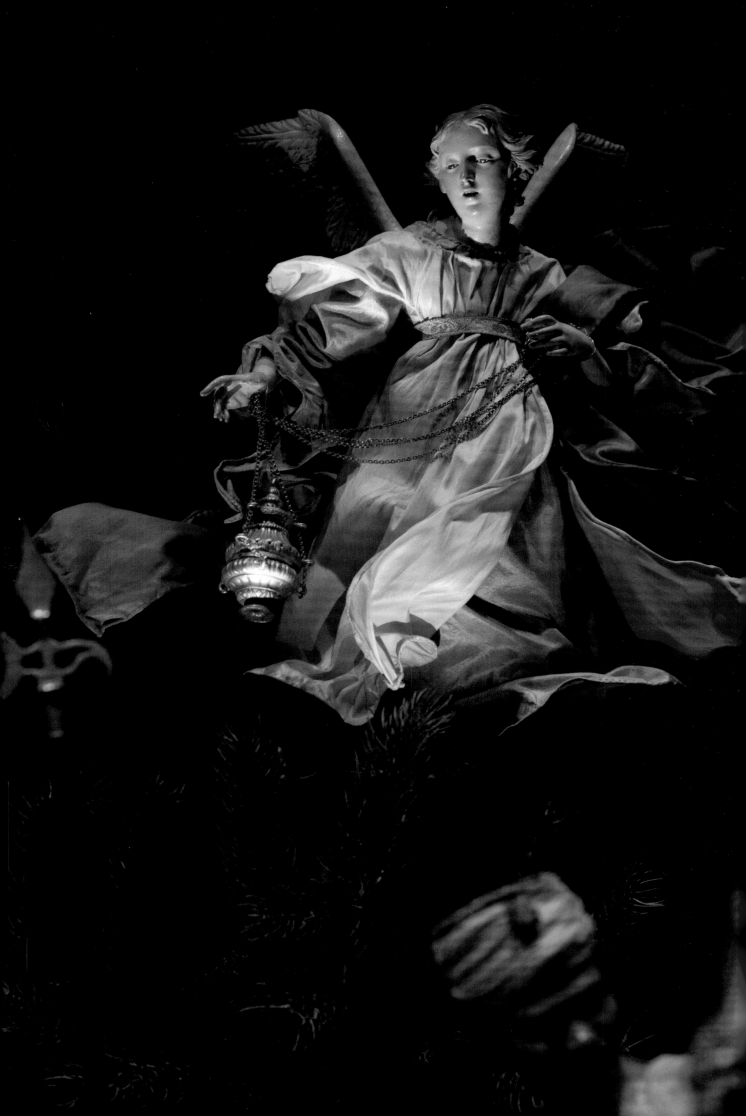

FOREWORD

FOR MORE THAN half a century now, the yearly exhibition of the Loretta Hines Howard collection of eighteenth-century Neapolitan crèche figures has been a much-anticipated event at the Metropolitan Museum. During the Christmas season, the crèche is displayed around a towering green tree, while small figures re-enact Christ's Nativity and act as the colorful pilgrims who come to visit him. They evoke the Baroque period in Naples, when celebrating Christmas in this way became a passion and leading artists were commissioned by noble families to create elaborate crèche scenes.

Through the years, Mrs. Howard's presentation of her crèche collection has brought joy to millions of Museum visitors of all ages. Some fifty angels, with finely sculpted heads and clothes of rustling silk, are suspended in the tree as if hovering in the heavens. Figures of Neapolitans and exotic travelers from the East enliven the landscape below.

We are most grateful to Mrs. Howard for her magnificent gift to the Metropolitan and the many years she spent creating and re-creating the installation. We particularly want to thank her daughter, Linn Howard, and her granddaughter, Andrea Selby, who continue her work by designing new scenes to delight viewers. The holiday season at the Museum is greatly enriched by their artistry and dedication.

Thomas P. Campbell
Director, The Metropolitan Museum of Art

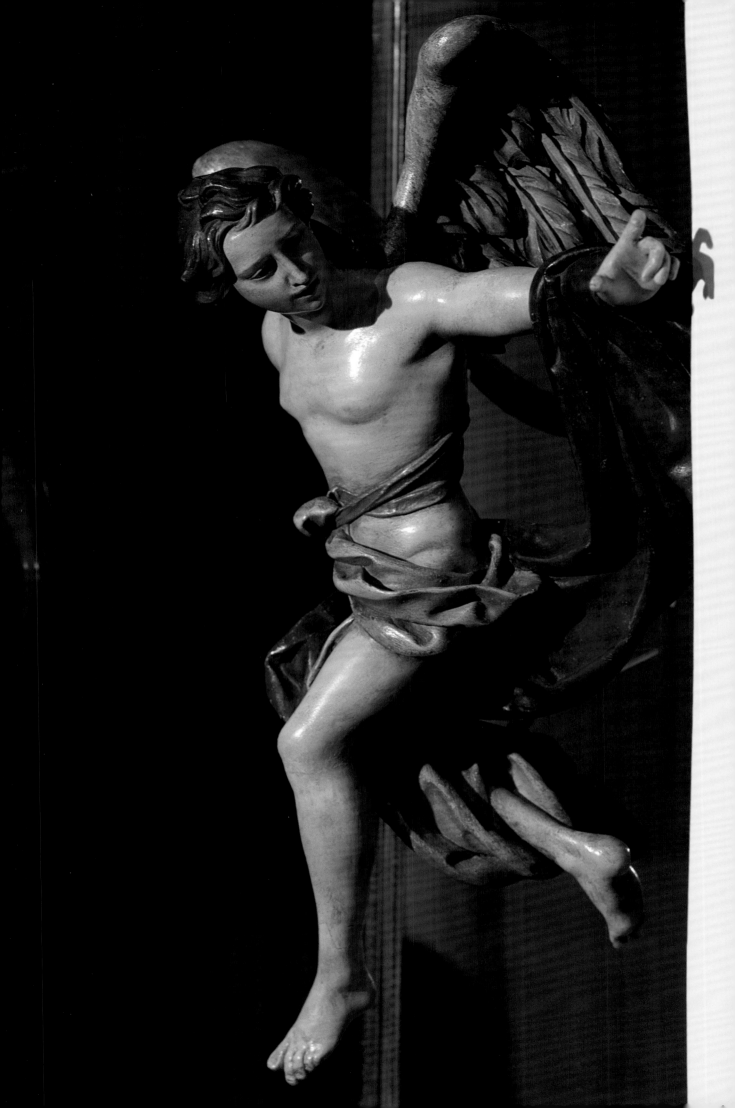

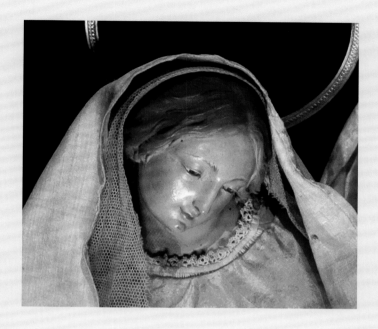

The CHRISTMAS STORY

THE ANGEL GABRIEL was sent from God unto a city of Galilee, named Nazareth,

To a virgin espoused to a man whose name was Joseph, of the house of David; and the virgin's name was Mary.

And the angel came in unto her, and said, Hail, thou that art highly favoured, the Lord is with thee: blessed art thou among women.

And when she saw him, she was troubled at his saying, and cast in her mind what manner of salutation this should be.

And the angel said unto her, Fear not, Mary: for thou hast found favour with God.

And, behold, thou shalt conceive in thy womb, and bring forth a son, and shalt call his name JESUS.

He shall be great, and shall be called the Son of the Highest . . . and of his kingdom there shall be no end.

Luke 1:26–33

11

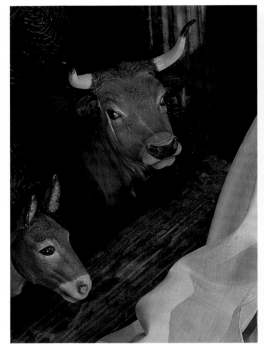
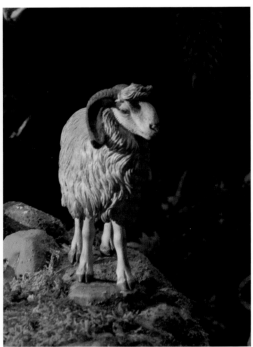

AND IT CAME TO PASS in those days, that there went out a decree from Caesar Augustus, that all the world should be taxed. . . .

And all went to be taxed, every one into his own city.

And Joseph also went up from Galilee, out of the city of Nazareth, into Judea, unto the city of David, which is called Bethlehem . . .

To be taxed with Mary his espoused wife, being great with child.

And so it was, that, while they were there, the days were accomplished that she should be delivered.

And she brought forth her firstborn son, and wrapped him in swaddling clothes, and laid him in a manger; because there was no room for them in the inn.

And there were in the same country shepherds abiding in the field, keeping watch over their flock by night.

And, lo, the angel of the Lord came upon them, and the glory of the Lord shone round about them; and they were sore afraid.

Luke 2:1, 3–9

PREVIOUS SPREAD, LEFT
A completely sculptured terra-cotta angel with colorful drapery and heroic wings is attributed to Francesco Celebrano. He was a painter and sculptor awarded many commissions by Ferdinando IV.

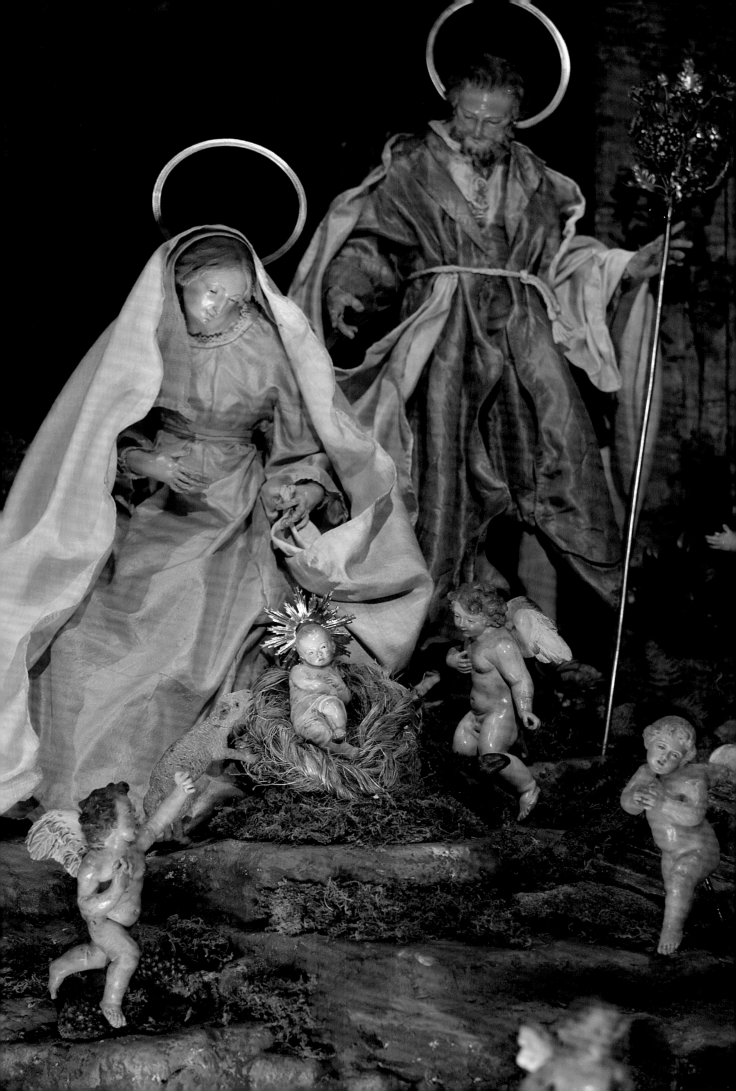

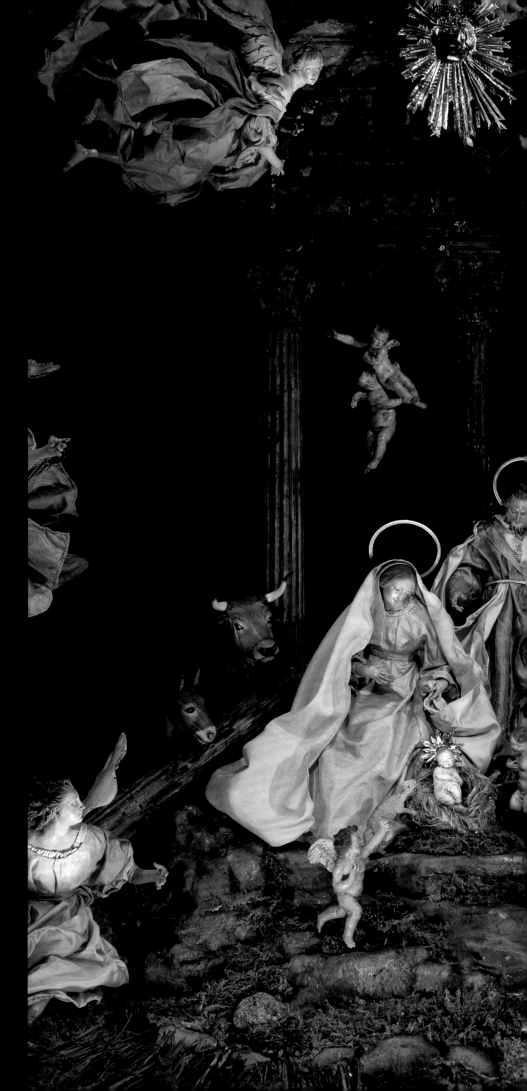

The Infant Jesus and the
two cherubs directly above
Mary are attributed to the
renowned sculptor Giuseppe
Sanmartino, who was consid-
ered the leading Neapolitan
sculptor of the eighteenth
century. His interest in mod-
eling crib figures points to
their importance during this
period.

 The Virgin Mary and
St. Joseph are attributed to
Salvatore di Franco, one
of Sanmartino's most tal-
ented pupils. The figures
are dressed in fine silks and
linens, and their haloes are
of silver gilt. St. Joseph's
golden staff is flowering
with lilies, peonies, roses,
and chrysanthemums. The
symbol of the Holy Ghost is
a golden dove with outspread
wings, resting on a silver
aureole with radiating rays.

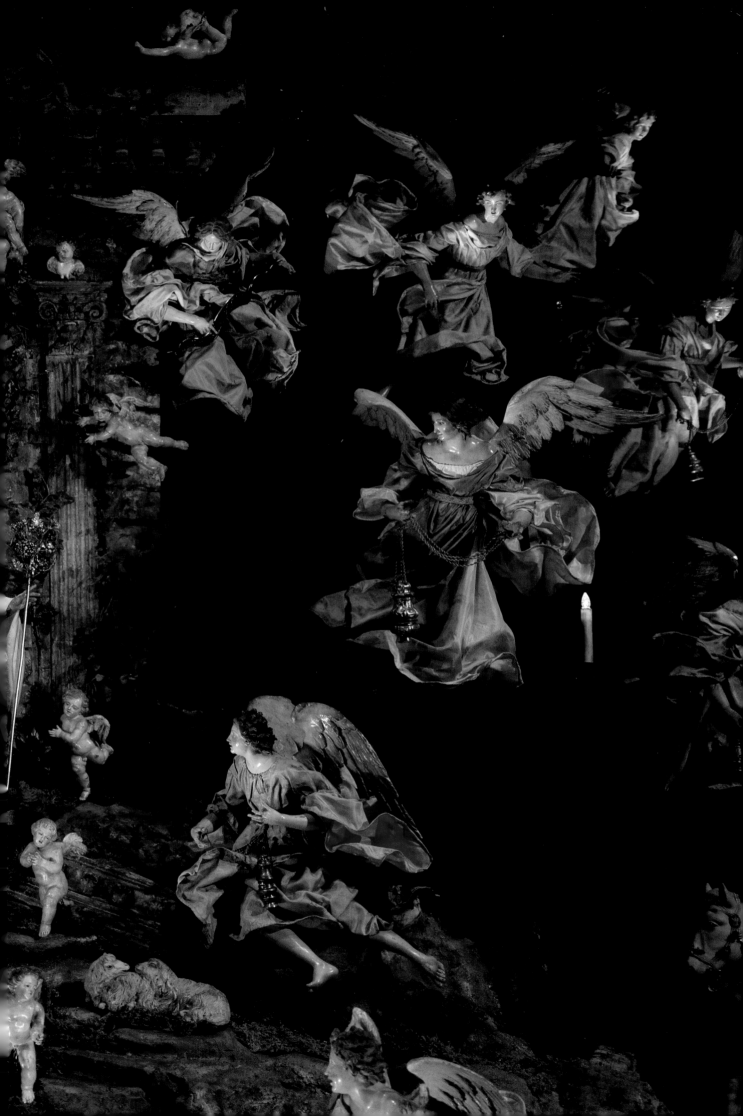

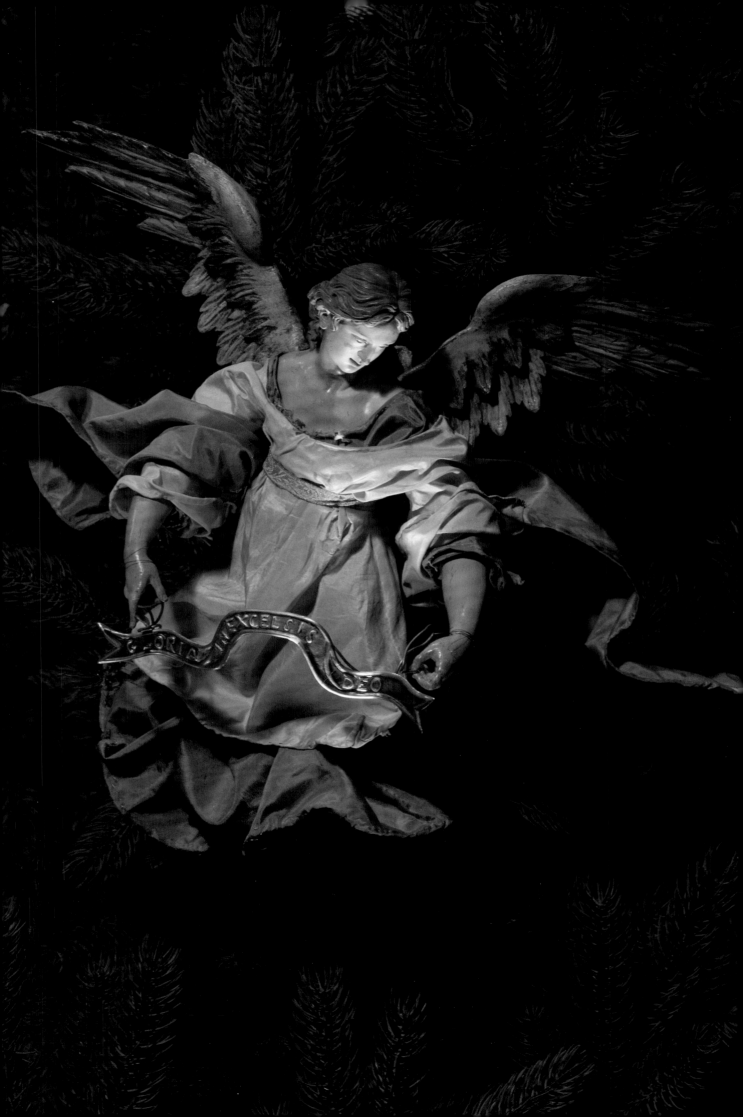

AND THE ANGEL said unto them, Fear not: for, behold, I bring you good tidings of great joy, which shall be to all people.

For unto you is born this day in the city of David a Saviour, which is Christ the Lord.

And this shall be a sign unto you; Ye shall find the Babe wrapped in swaddling clothes, lying in a manger.

And suddenly there was with the angel a multitude of the heavenly host praising God, and saying,

Glory to God in the highest, and on earth peace, good will toward men.

And it came to pass, as the angels were gone away from them into heaven, the shepherds said one to another, Let us now go even unto Bethlehem, and see this thing which is come to pass, which the Lord hath made known unto us.

And they came with haste, and found Mary and Joseph, and the Babe lying in a manger.

And when they had seen it, they made known abroad the saying which was told them concerning this child.

And the shepherds returned, glorifying and praising God for all the things that they had heard and seen, as it was told unto them.

Luke 2:10–17, 20

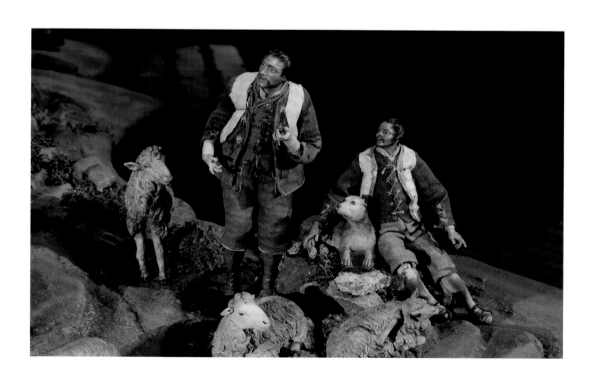

NOW WHEN JESUS was born in Bethlehem . . . behold, there came wise men from the east to Jerusalem,

Saying, Where is he that is born King of the Jews? for we have seen his star in the east, and are come to worship him.

. . . And, lo, the star, which they saw in the east, went before them, till it came and stood over where the young child was.

When they saw the star, they rejoiced with exceeding great joy.

And when they were come into the house, they saw the young child with Mary his mother, and fell down, and worshipped him: and when they had opened their treasures, they presented unto him gifts; gold, and frankincense, and myrrh.

Matthew 2: 1–2, 9–11

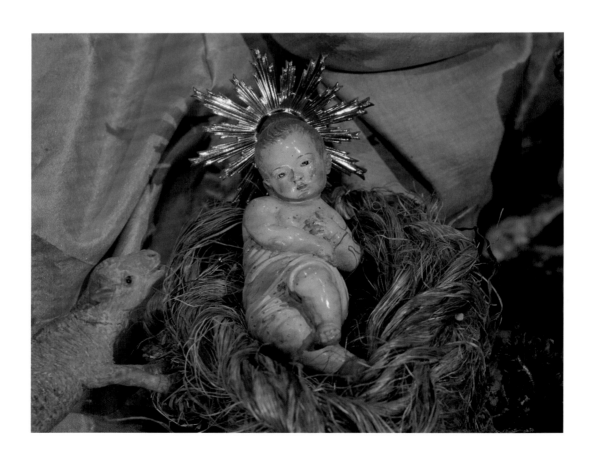

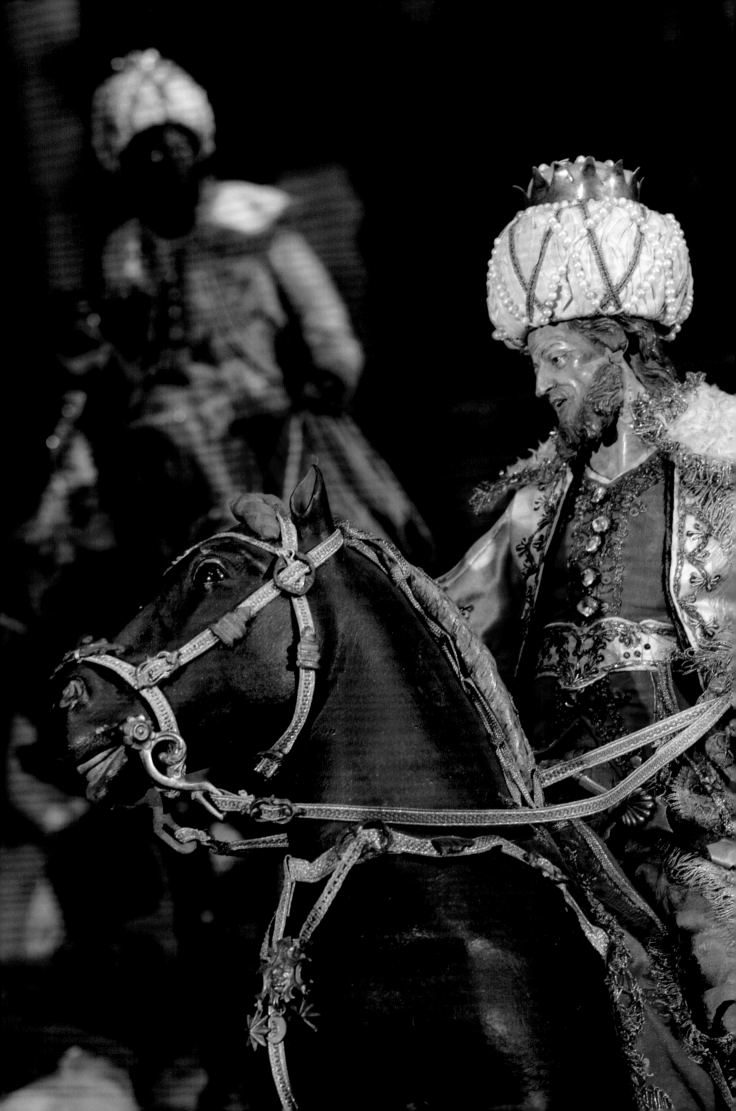

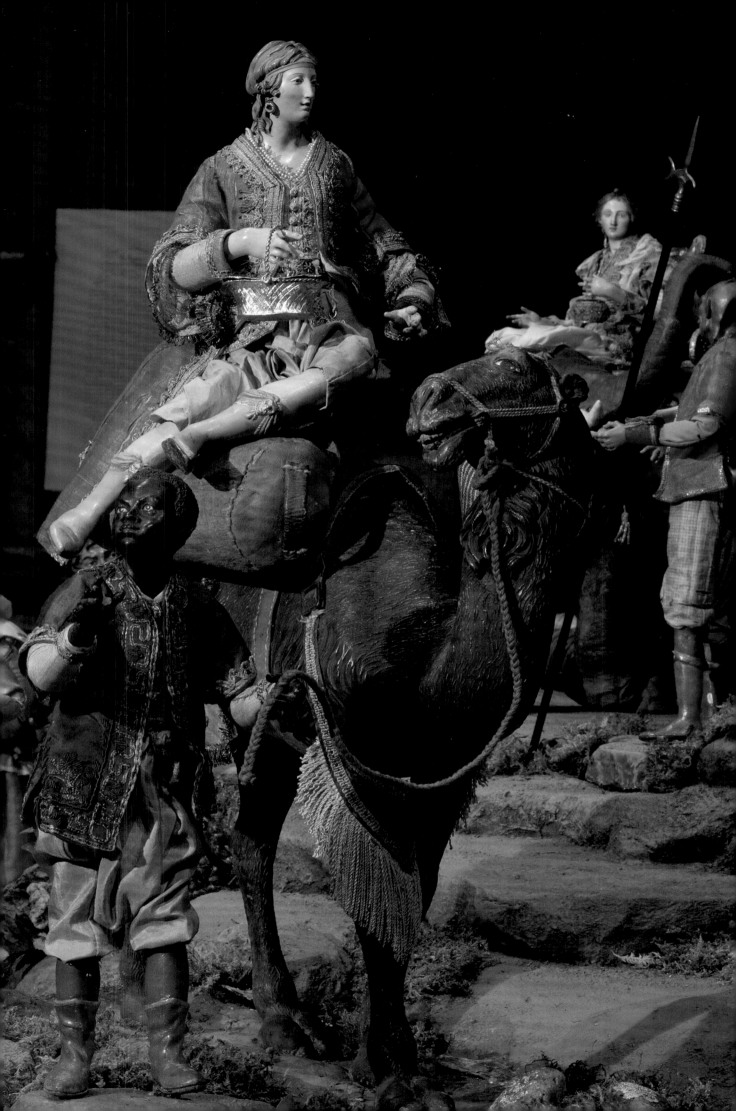

The CRÈCHE in Eighteenth-Century NAPLES

THE IDEA OF celebrating the Nativity in lifelike form flourished in Naples in the eighteenth century, during the reign of the Bourbon kings. Noble families called on leading artists to create small figures they could collect and display in elaborate settings in their palaces during the holy Christmas season. It is reported that the collection of King Don Carlos numbered almost six thousand figures. Ferdinando IV, who acceded to the throne in 1759, reveled in the making of figures for his family's crèche. His queen, Maria Carolina, and her ladies dressed the angels, Magi, and exotic pilgrims in fashionable silks and embroideries encrusted with real jewels. Figures of local tradespeople and shepherds were dressed in homespun and sheepskin and shown bringing their wares and their animals to the manger.

These flexible little figures, often no more than twenty inches tall, were made of hemp, tow, and wire, with arms and legs finely carved of wood. Their terra-cotta heads were sculpted and polychromed by renowned artists whose monumental works appeared in local museums and churches. Many artists took great pleasure in the creation of figures, animals, and objects for the crèches. Two of the masters were Giuseppe Sanmartino, considered the leading Neapolitan sculptor of the period, and his famous pupil Salvatore di Franco, who created some of the most beautiful Nativity figures and angels.

At Christmastime, it was the custom of Neapolitans to travel around the city to churches and houses to admire and enjoy the great variety of *presepi*, as they were called in Naples. Some collections were major theatrical productions, set in dramatic architectural

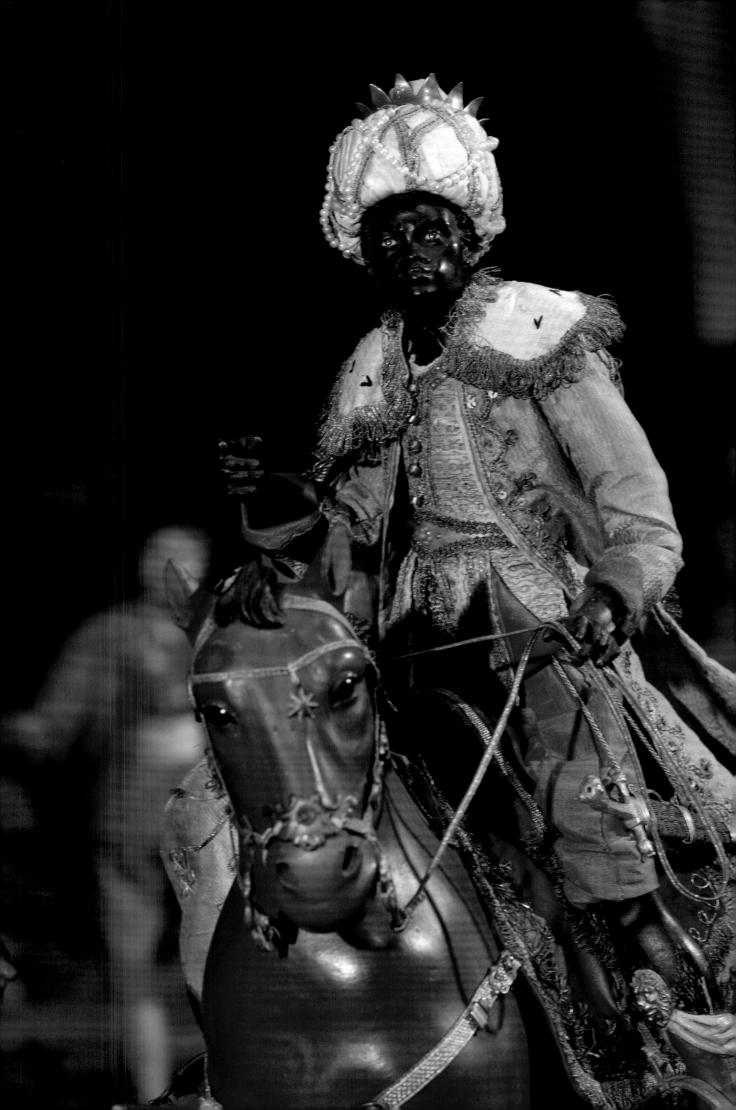

backgrounds with music and lights. The city itself was ablaze with fireworks and alive with music. It has been suggested that during this period Naples was a city of light and fire second only to Paris in creativity. The eighteenth-century Neapolitan crèches, now so prized by collectors, reflect the religious ardor and multicultural splendor of this magnificent Baroque city.

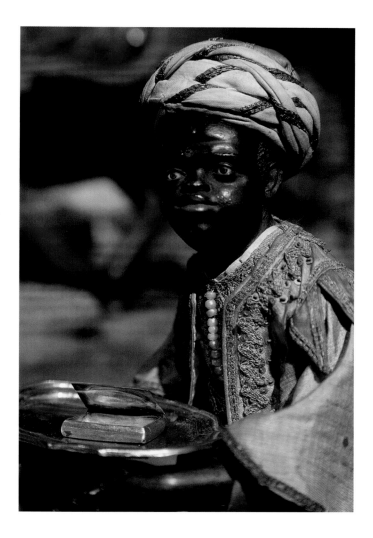

PRECEDING SPREAD, LEFT
A bejeweled noble lady, attributed to Giuseppe Gori, arrives on a camel led by a young attendant. She brings her presents for the Christ Child in a covered silver basket.

OPPOSITE AND ABOVE
A Moorish king wears a jacket of green silk embellished with gold braid. His white cape is decorated with berry and flower designs. His horse sports a golden bridle. The king's young attendant, carrying a silver tray with a copper snuffbox, is dressed in regal style, and he wears a string of real pearls.

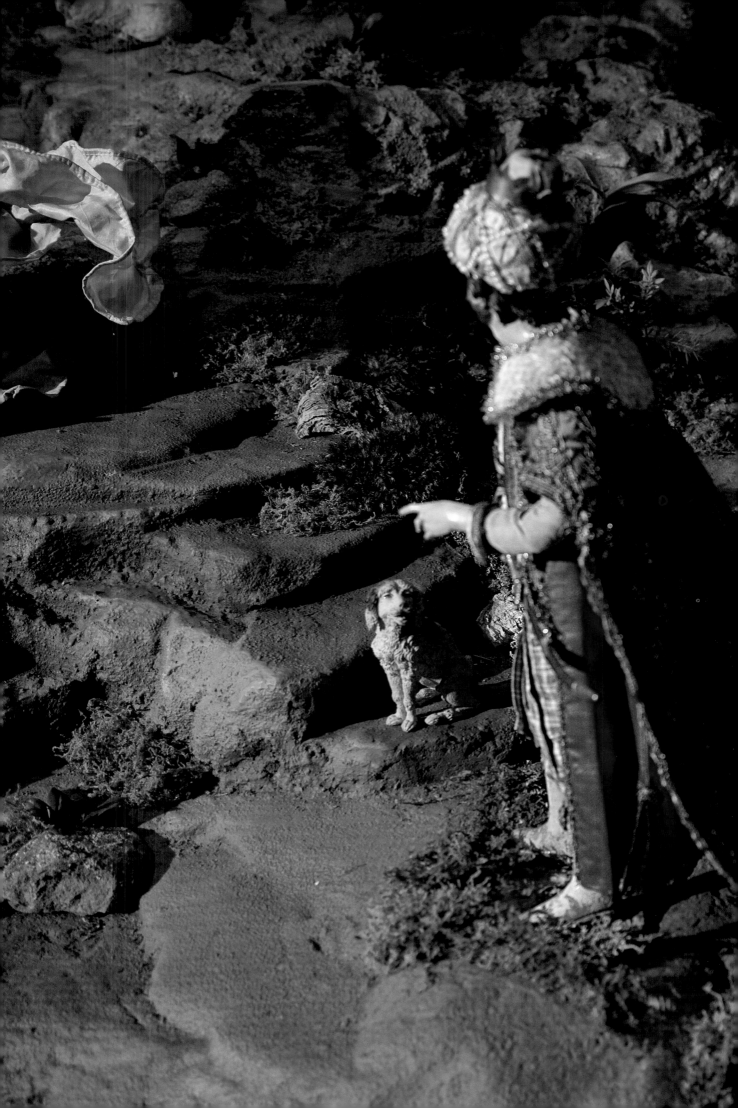

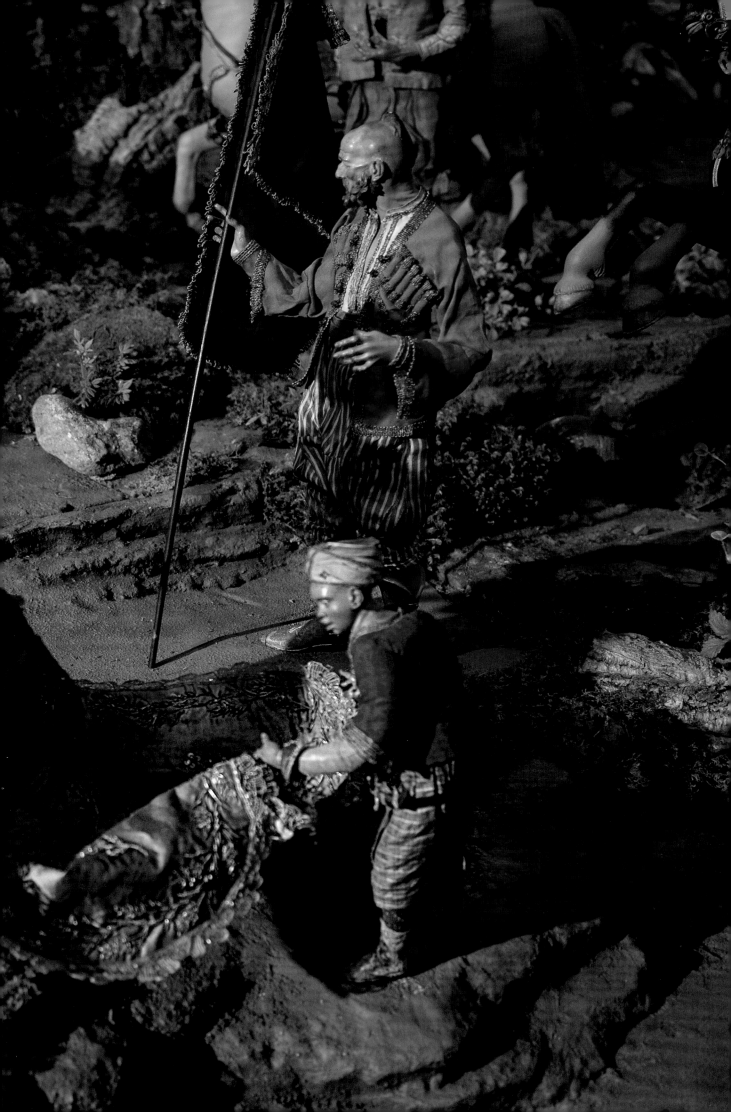

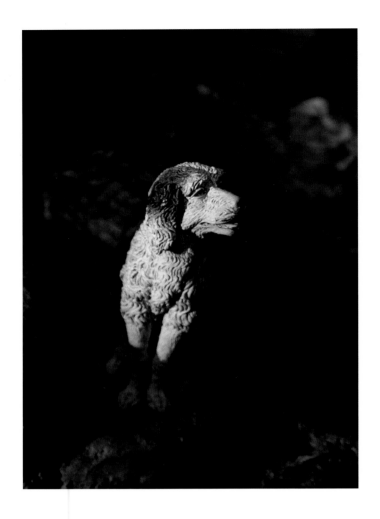

PRECEDING SPREAD

The walking king in his magnificent clothing is attributed to
Nicola Ingaldi. In 1862, Ingaldi's statue of the Virgin Mary
was inaugurated in the old Neapolitan Chiesa del Gesù in the
presence of royalty. His work appears in the crèche invento-
ries of kings Francesco I and Ferdinando II. The train of his
embroidered cape is carried by an attendant dressed in
Eastern style.

ABOVE AND OPPOSITE

The king, who has brought along his white poodle, carries a
silver-gilt sword with an animal-head hilt and a shell motif on
the handle. The dark red leather sheath has a silver-gilt tip. His
bejeweled turban is topped with a golden crown.

OVERLEAF

A groom, dressed in embroidered silks, is attributed to
Lorenzo Mosca. He holds the king's white horse, with its
braided mane and luxurious trappings.

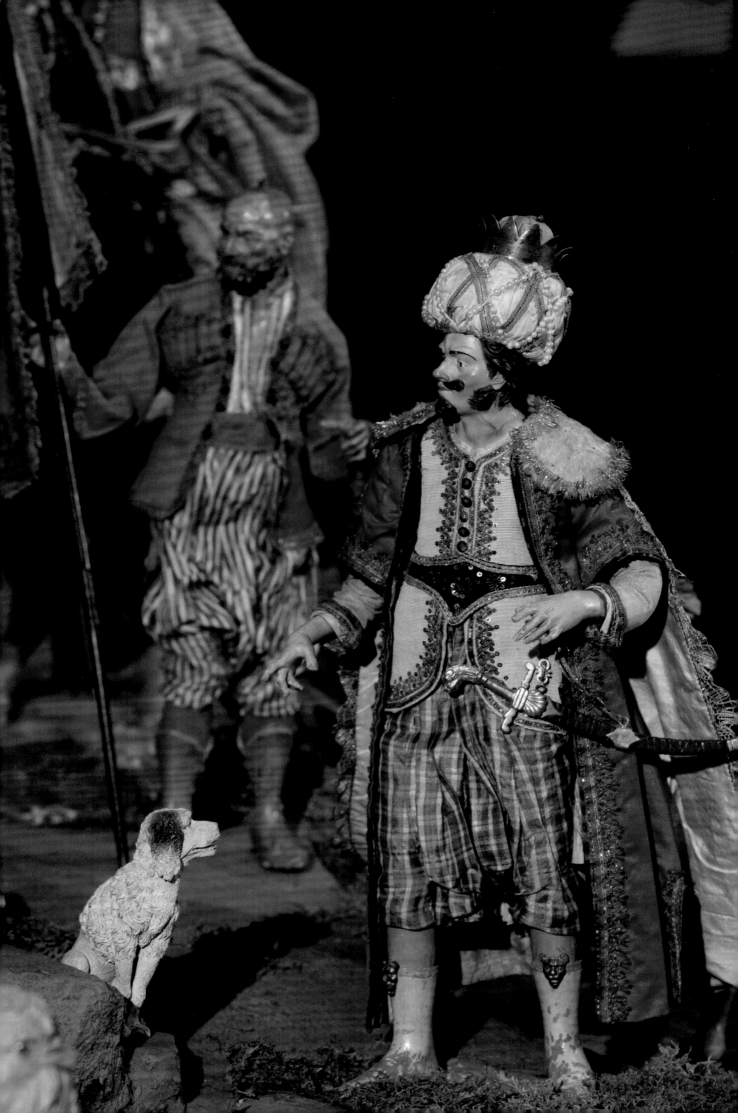

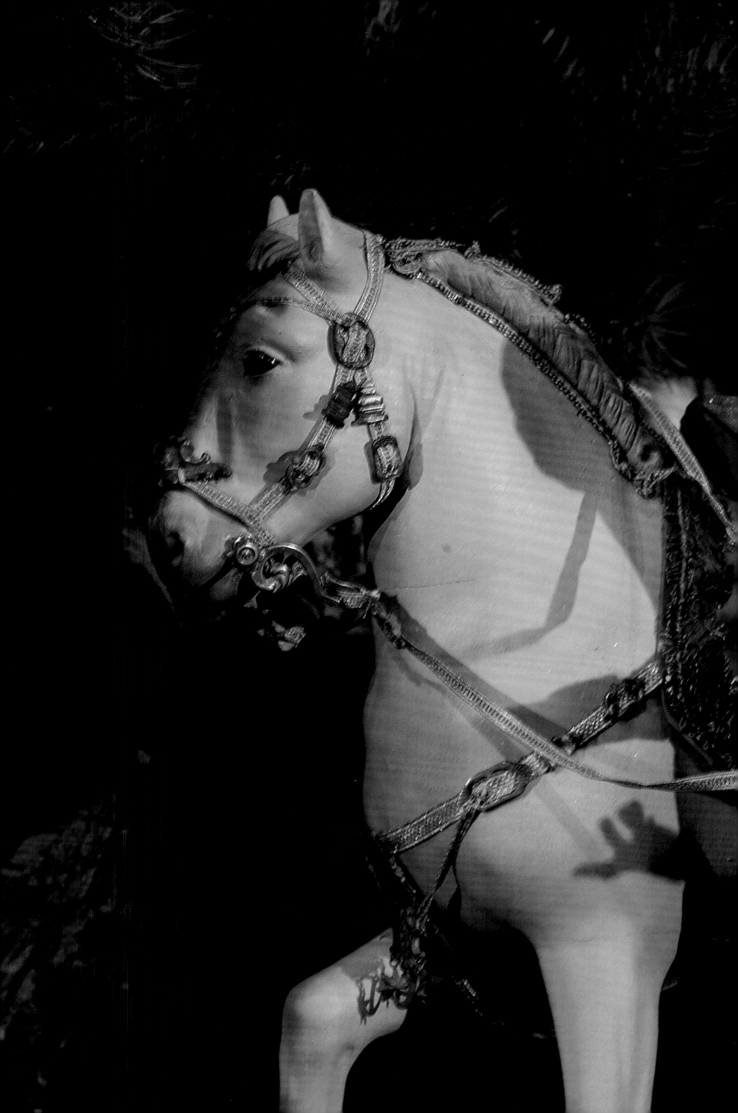

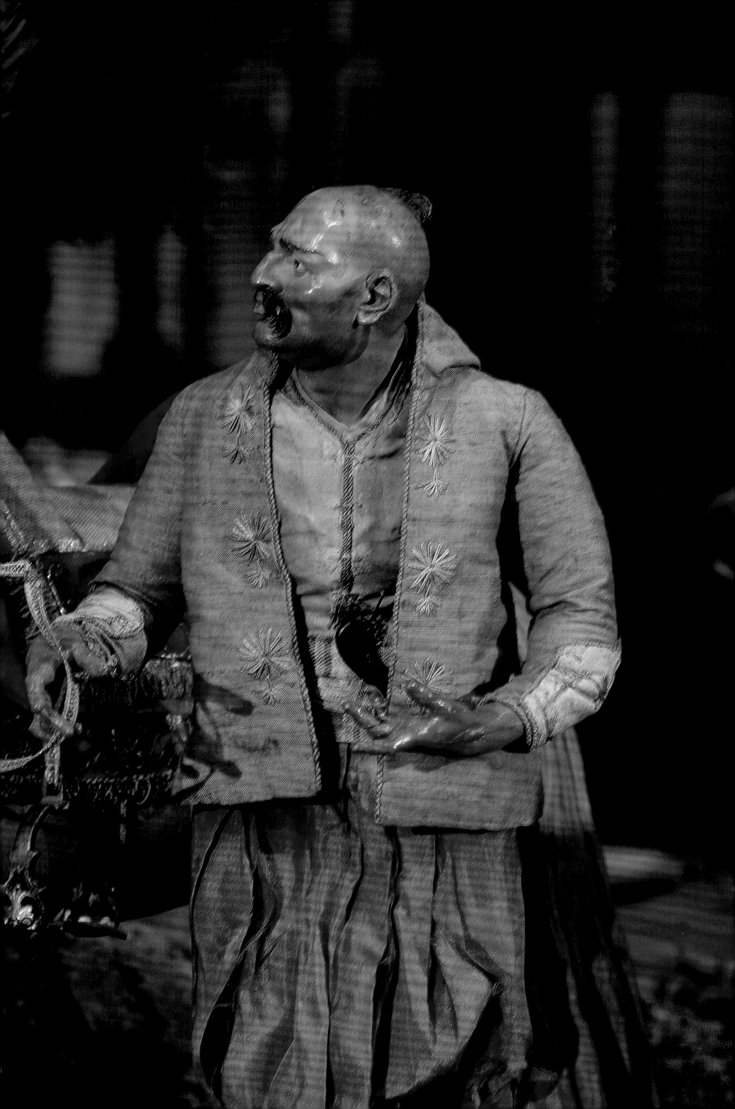

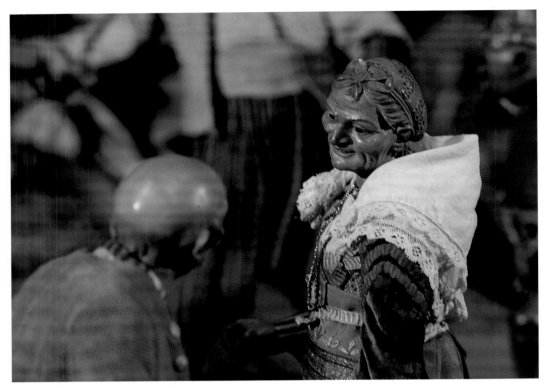

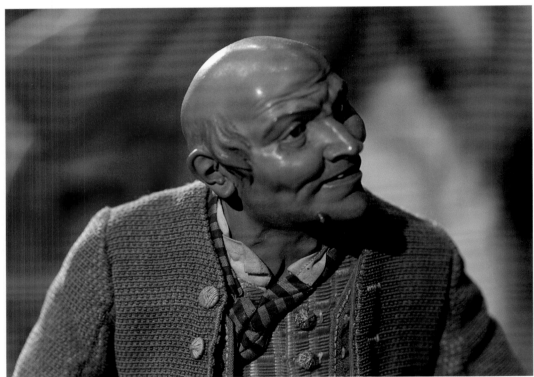

A prosperous couple follows the kings to the crib. The man, attributed to Lorenzo Mosca, wears two vests. Like his brown coat, they are fastened with large cloth buttons. His wife wears a silk and velvet dress with a romantic lace-trimmed collar.

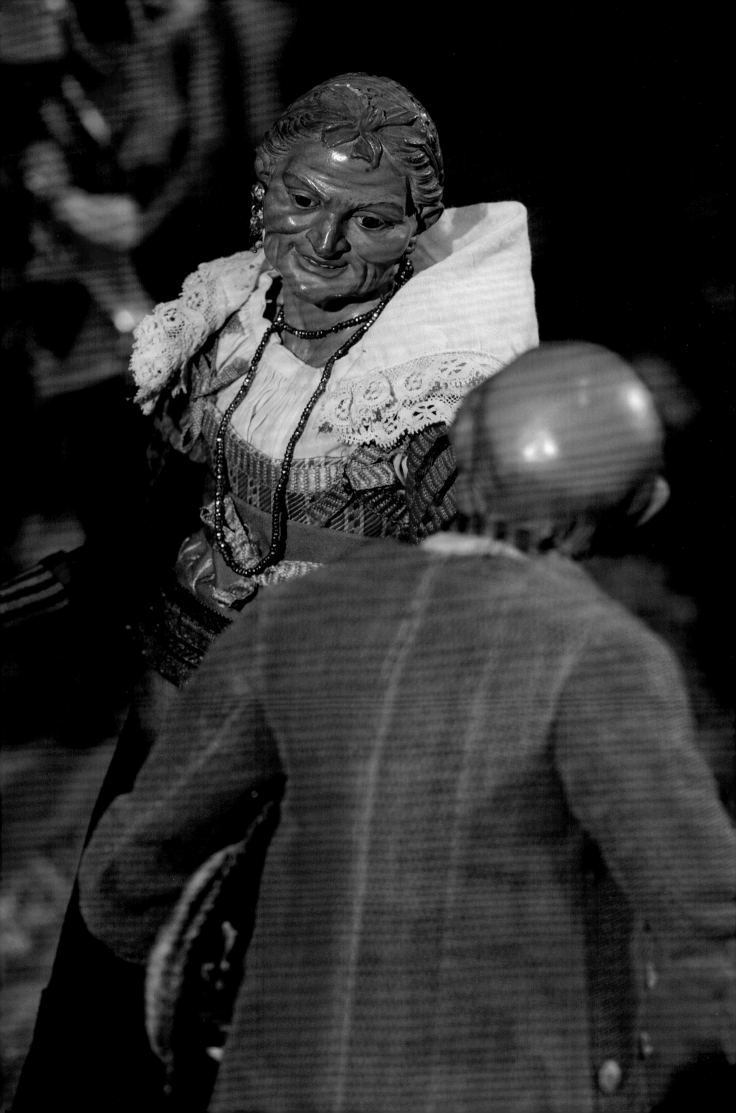

In the kings' entourage, a nobleman, attributed to Giuseppe Gori, wears a long blue coat trimmed with gold braid and leans on his ivory-topped walking stick as he pauses to rest his dogs. Both he and his attendant carry handsome brass swords.

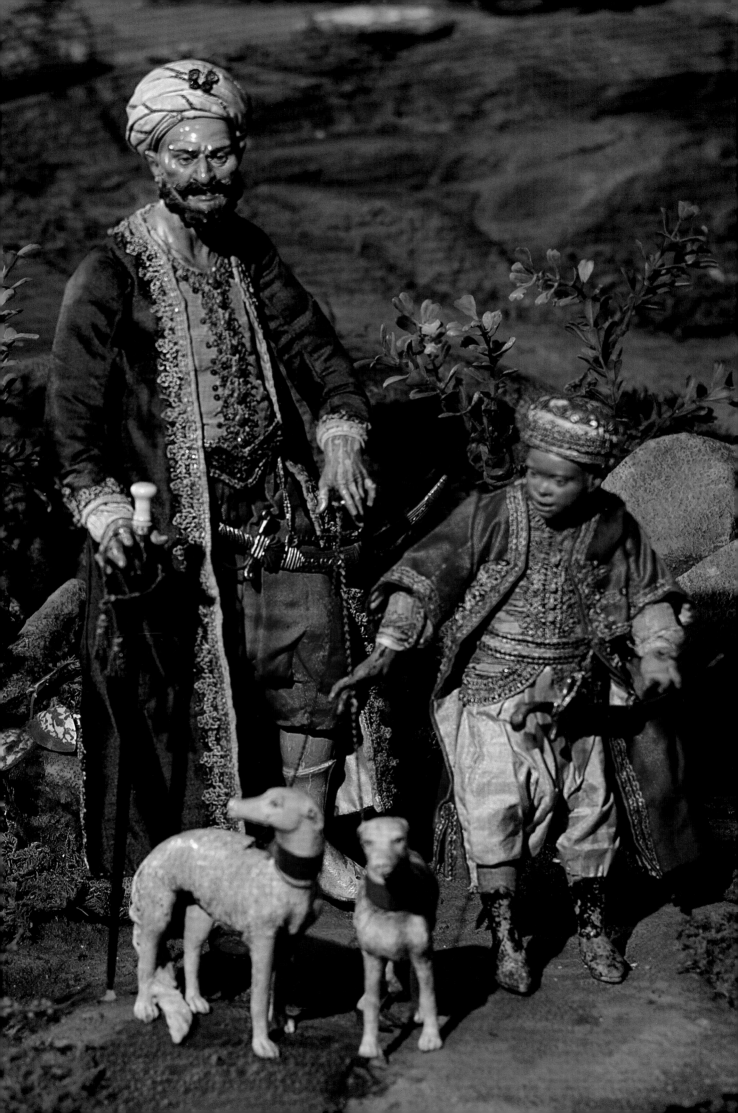

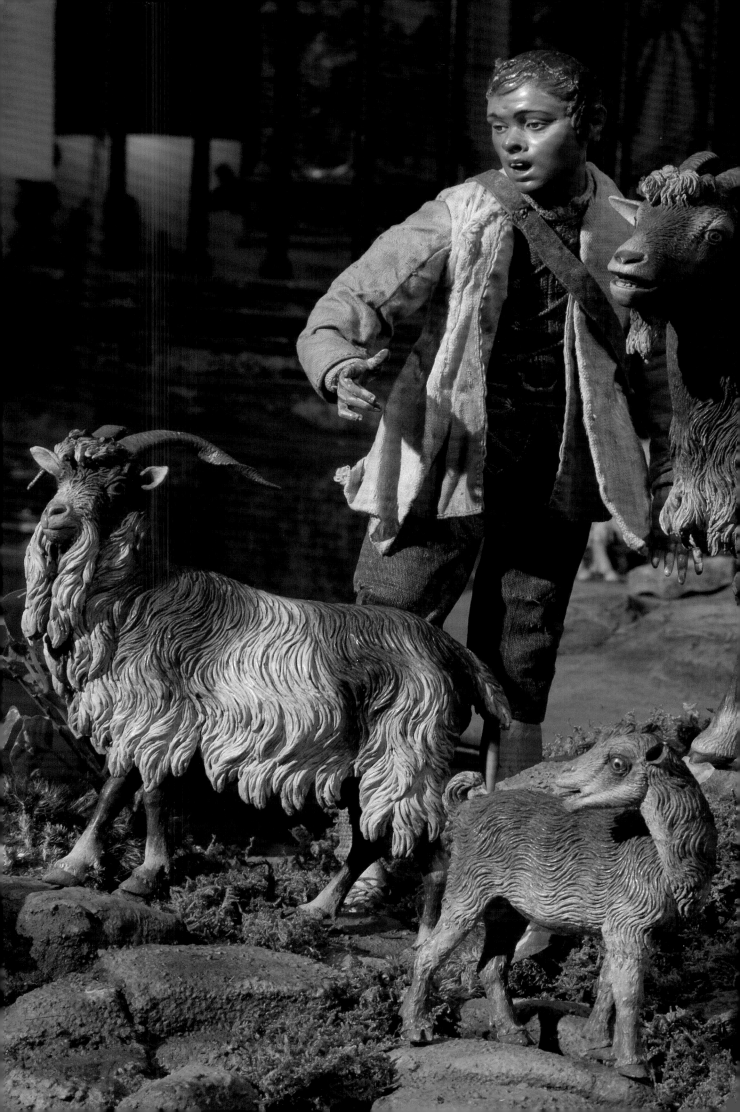

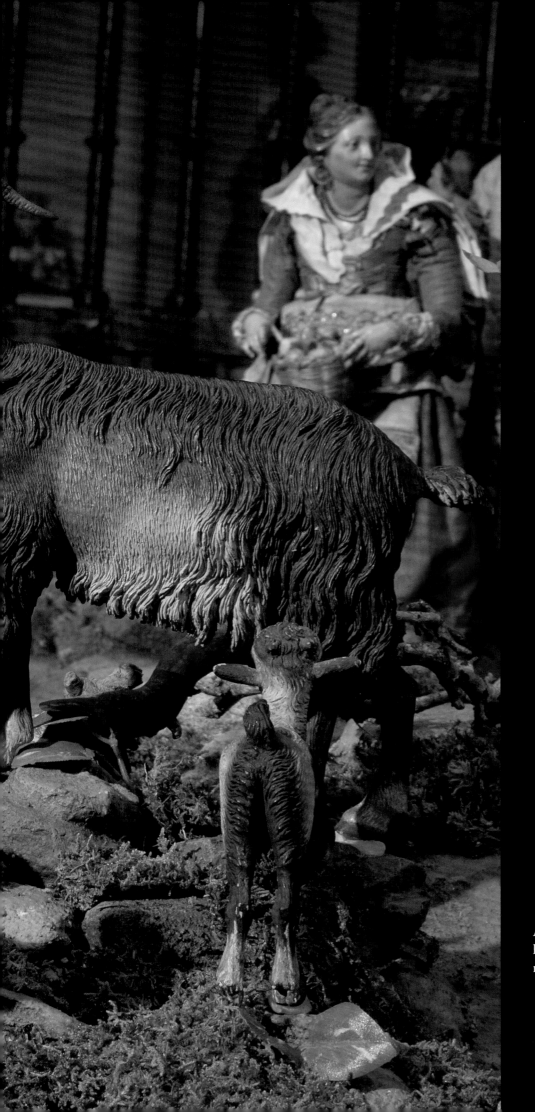

A shepherd dressed in homespun tends his goats. A mother goat nurses her kid.

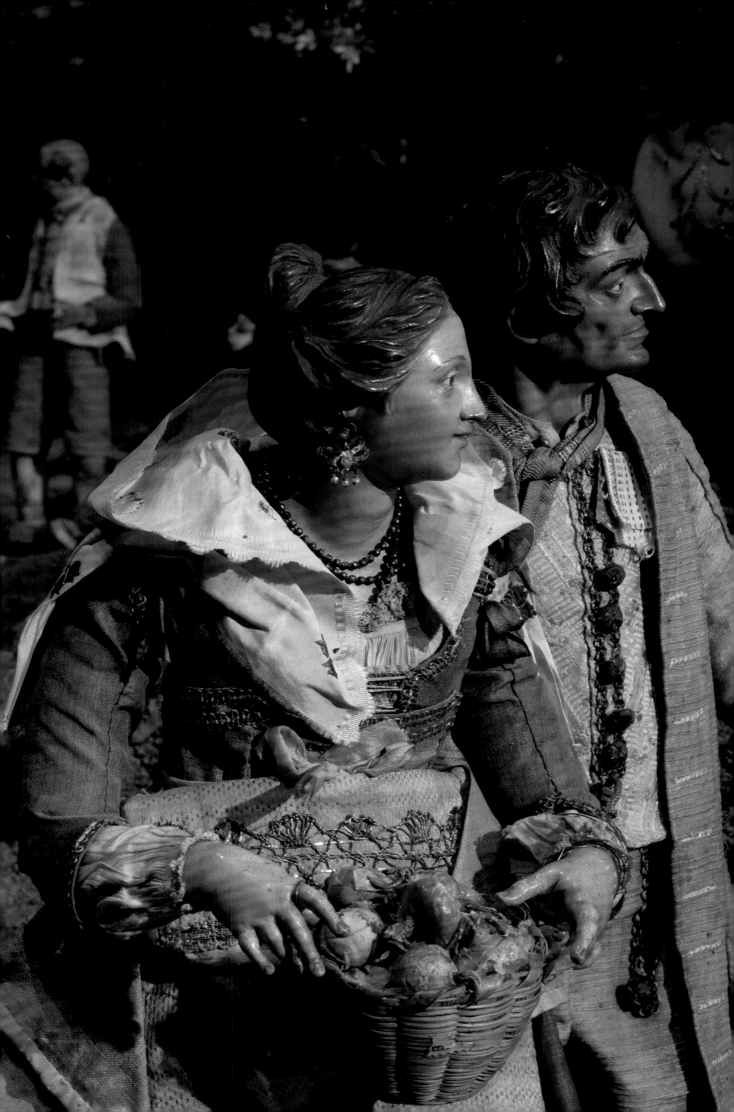

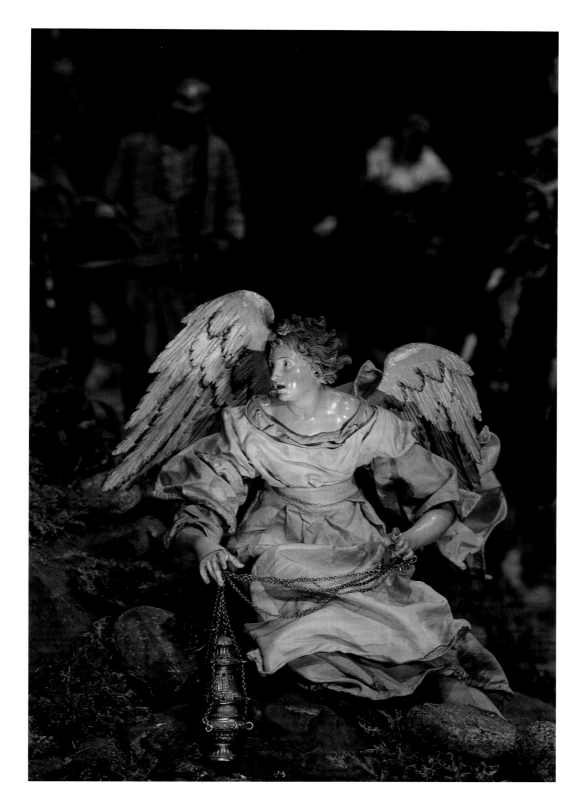

OPPOSITE, ABOVE, AND OVERLEAF

A handsomely dressed couple come from the market. Her
jacket is bright blue silk and she wears a golden earring with
swinging pearls. She carries a basket of onions. He wears a
bright blue neckerchief to set off his suit of champagne silk.
They seem to be admiring angels in their midst.

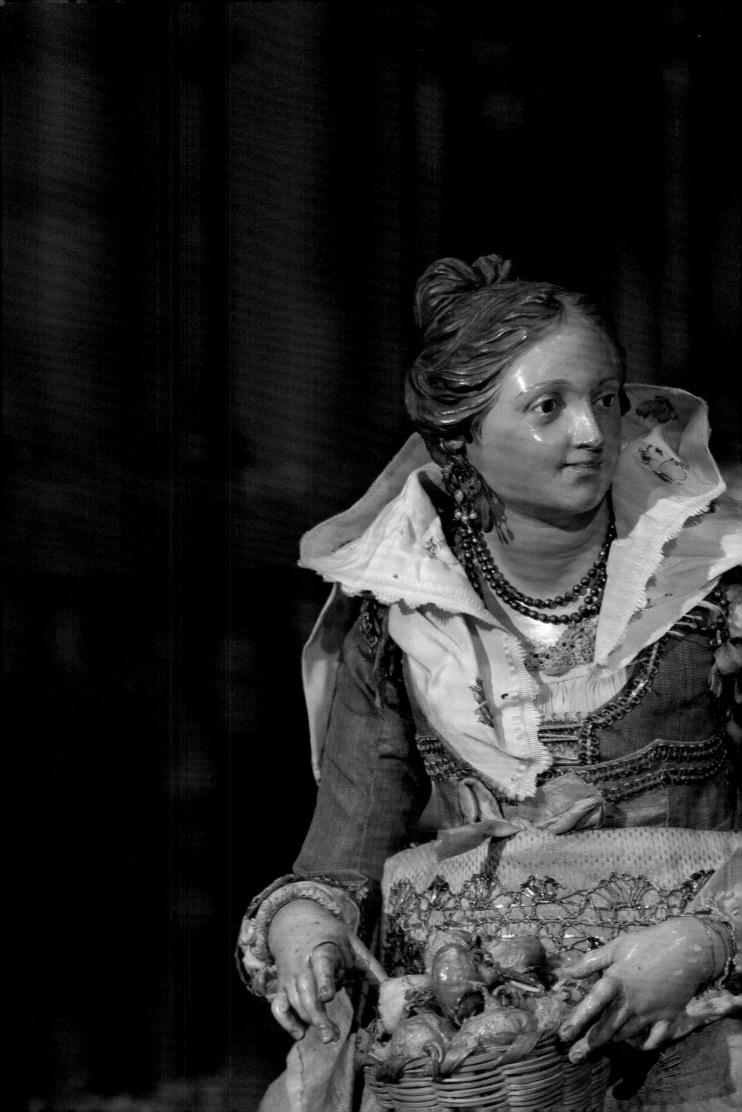

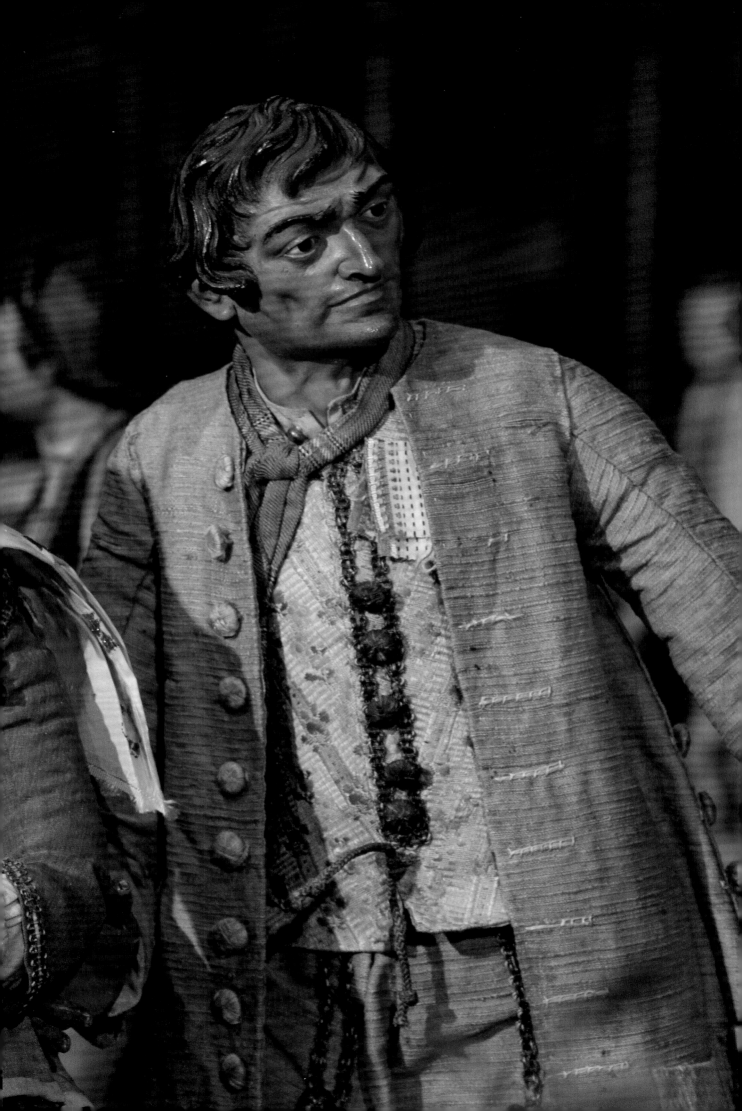

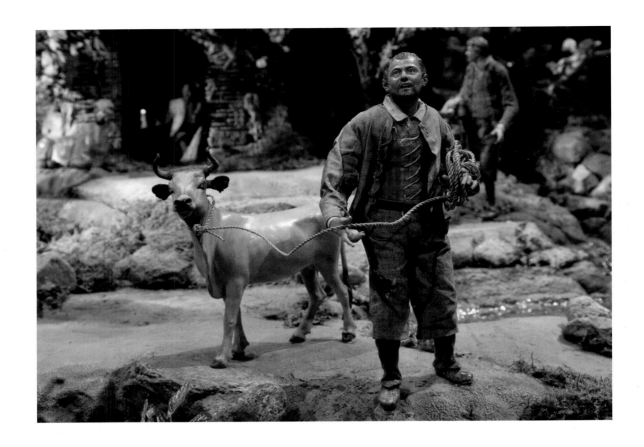

ABOVE

A shepherd dressed in his best clothes leads a finely sculpted young bull, attributed to Francesco Gallo, to the celebration. Gallo was highly praised for his realistic sculptures of crèche animals.

OPPOSITE

A noble couple pause on their way to the crib. They are finely dressed—her white headdress and apron are trimmed with lace, and his red suit and green vest are trimmed with gold braid. She is attributed to the artist Lorenzo Mosca.

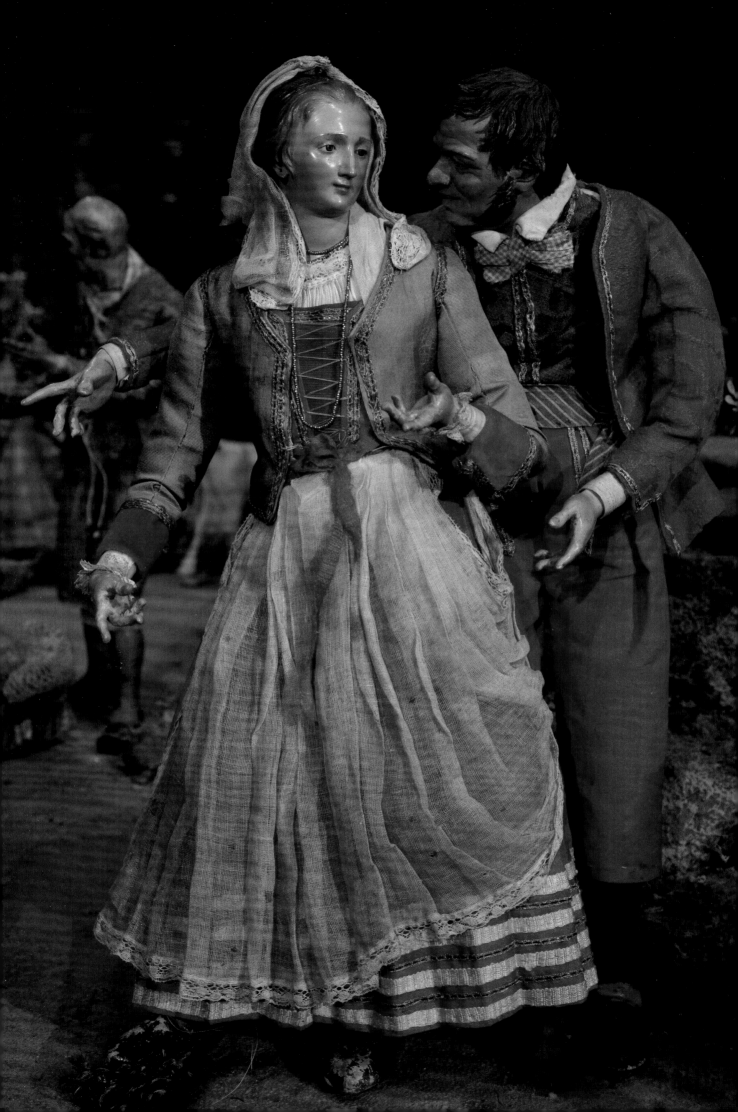

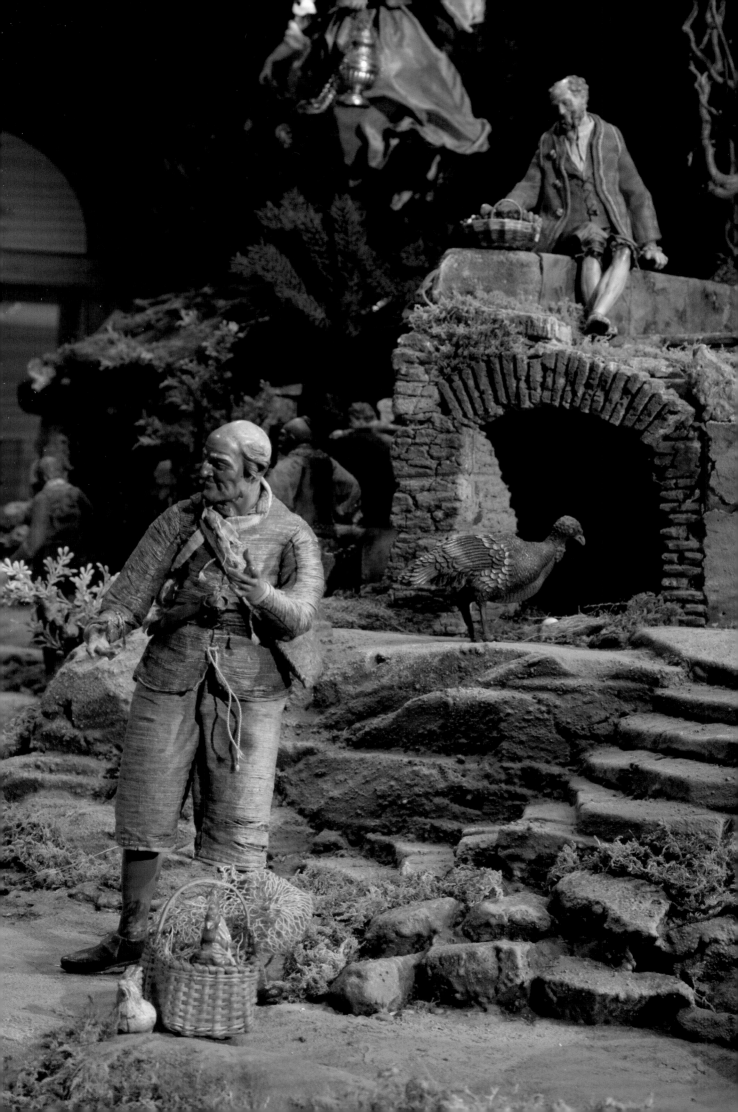

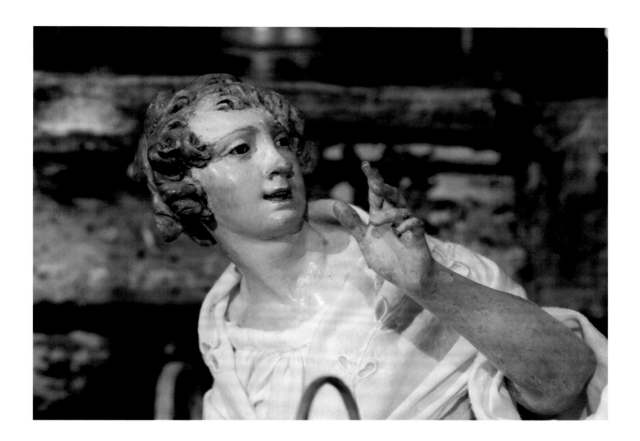

OPPOSITE
A poultry farmer brings a rooster and a hen to market.
On the roof of the stable, an elderly man in a red coat smiles
at the purchases in his basket. A turkey hen guards an egg in
her nest.

ABOVE
A vendor's wife beckons customers.

OVERLEAF
The vendor, attributed to Lorenzo Mosca, offers his wares to
the townsfolk passing by. His basket is filled with fruits and
vegetables. His wife, seated behind the stand, is surrounded
by baskets of cheese, bread, fruit, and eggs. She weighs red
sausages on the scale.

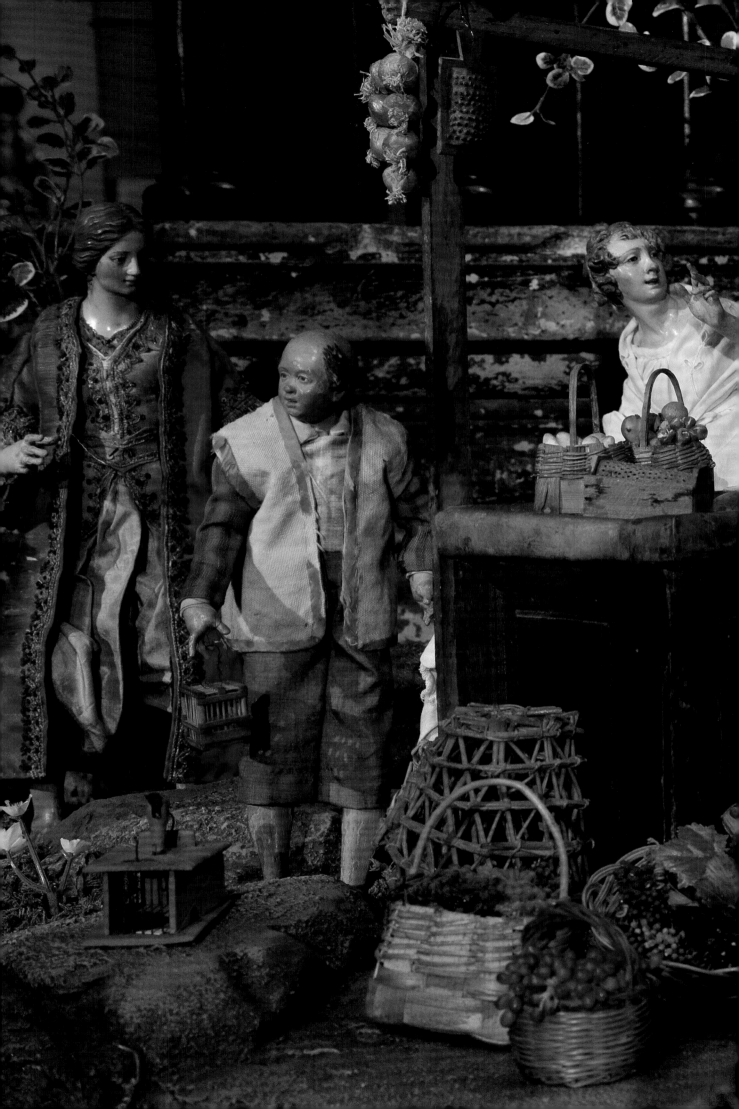

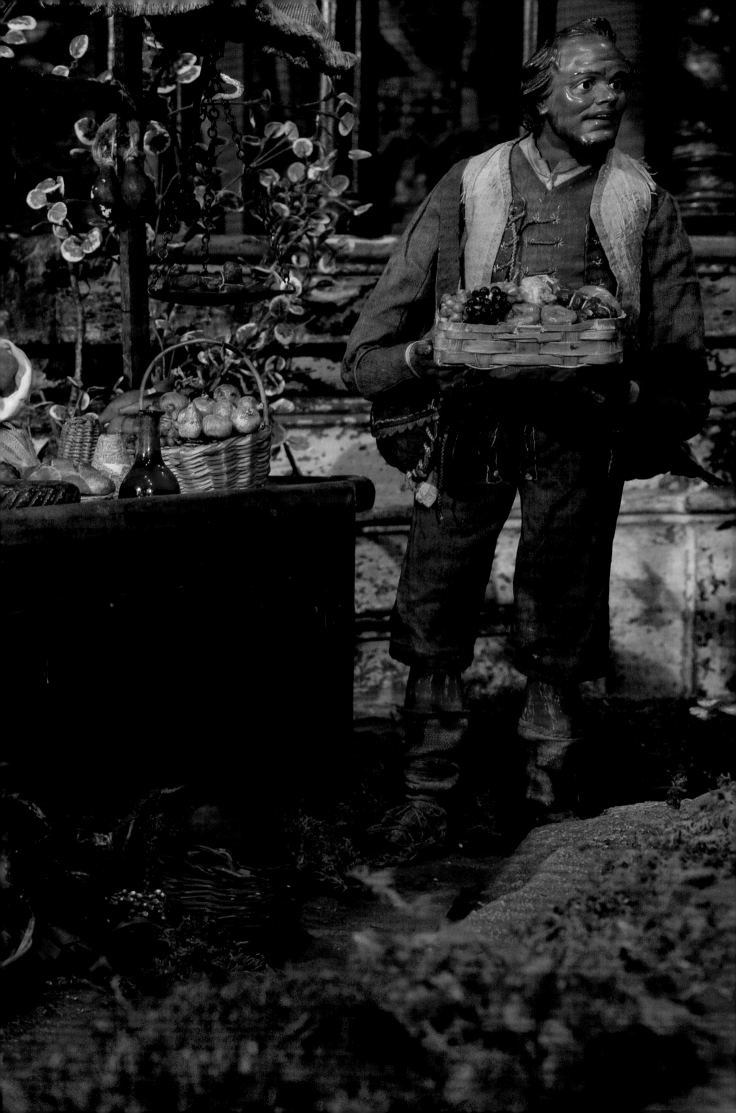

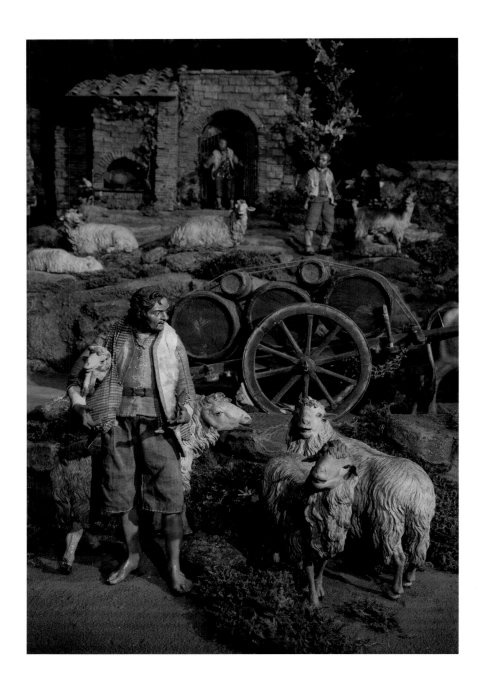

ABOVE

A shepherd carries a baby lamb in his sack. Two of the shepherd's flock are attributed to Francesco Gallo, who often used animals in the royal zoo in Naples for inspiration. One of the sheep is attributed to the Vassallo brothers.

OPPOSITE

A whippet with a silver collar and chain is led to the festivities by a young boy, part of a family representing three generations of Neapolitans—grandmother, mother and father, and son. All wear colorful costumes of the period. The whippet is attributed to Saverio Vassallo.

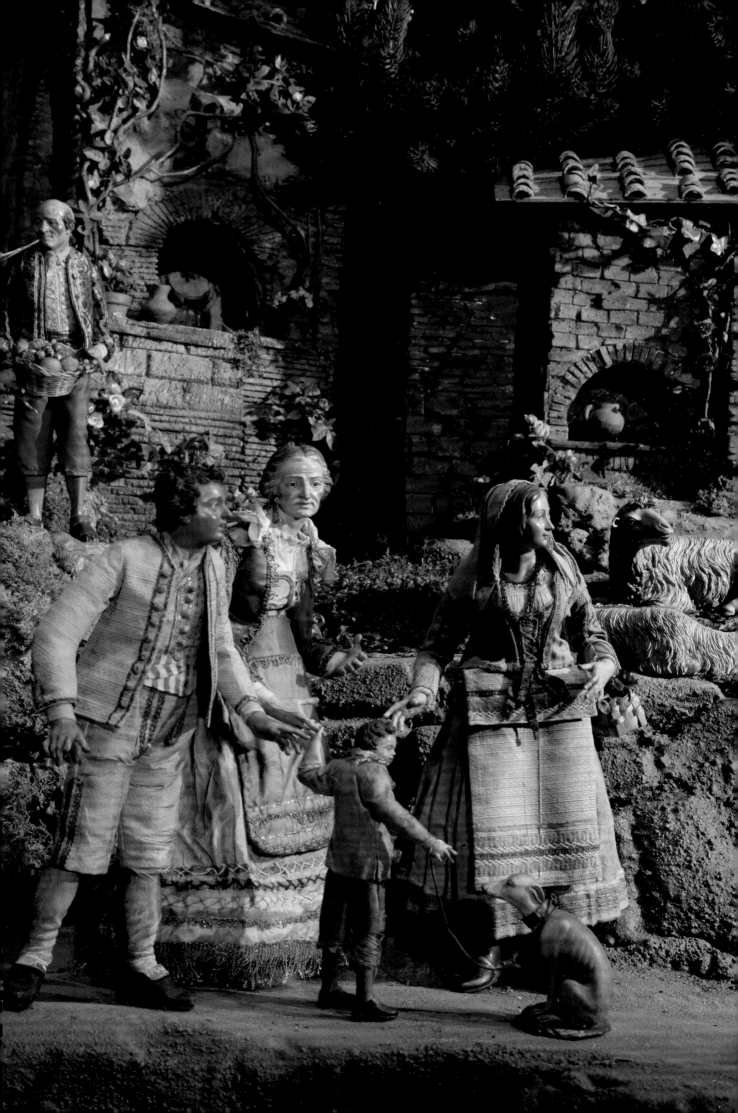

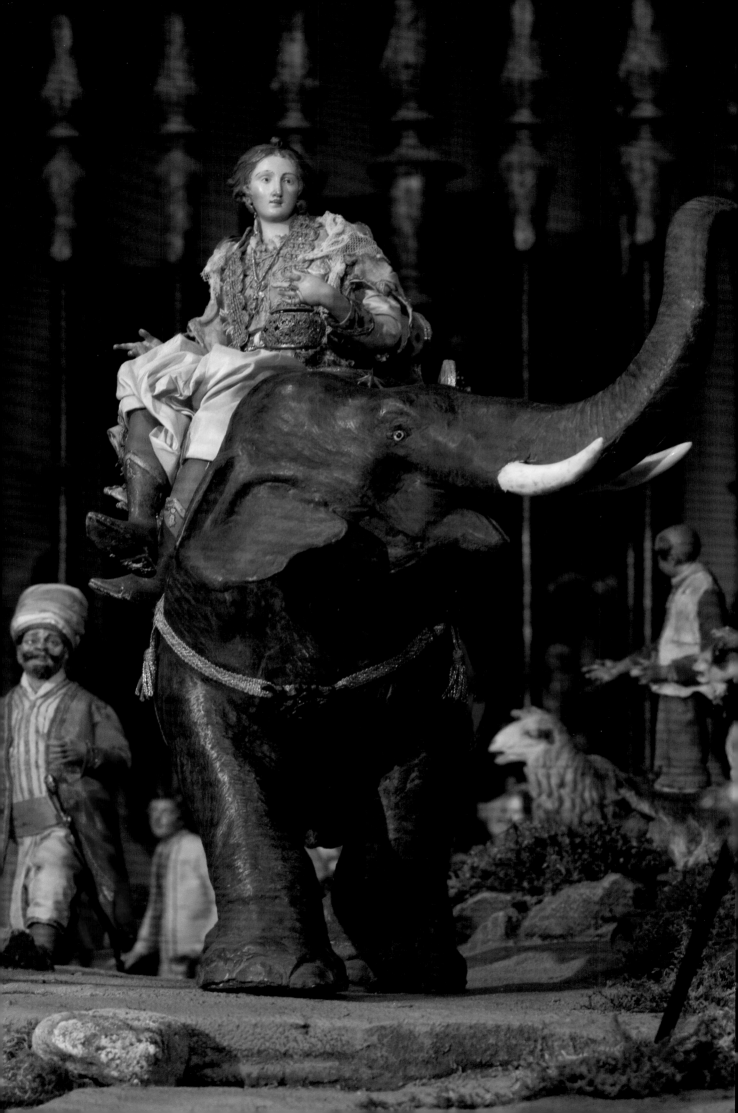

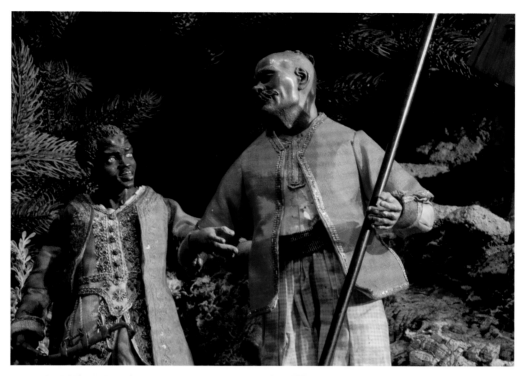

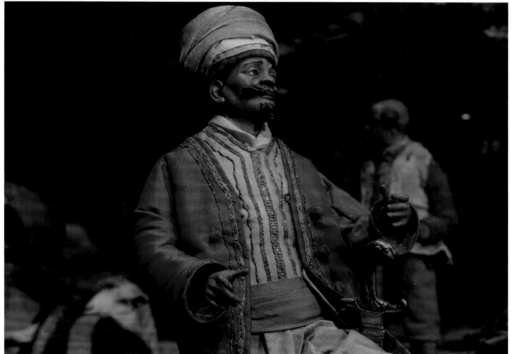

OPPOSITE, ABOVE, AND OVERLEAF
A lady comes to the crib riding her elephant. She sits in a
decorated howdah wearing embroidered silks and jewels. The
sheep is attributed to Giuseppe Gallo. Her elephant trainer
carries a halberd, and other attendants follow. All wear
costumes in colorful Eastern style.

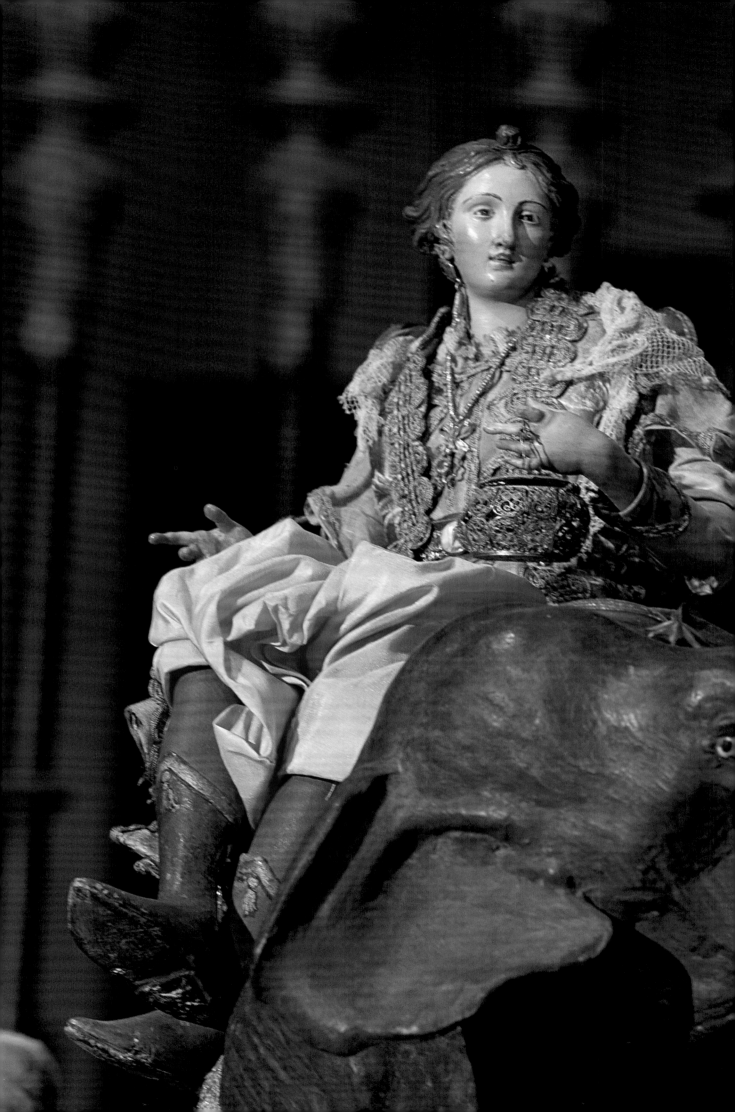

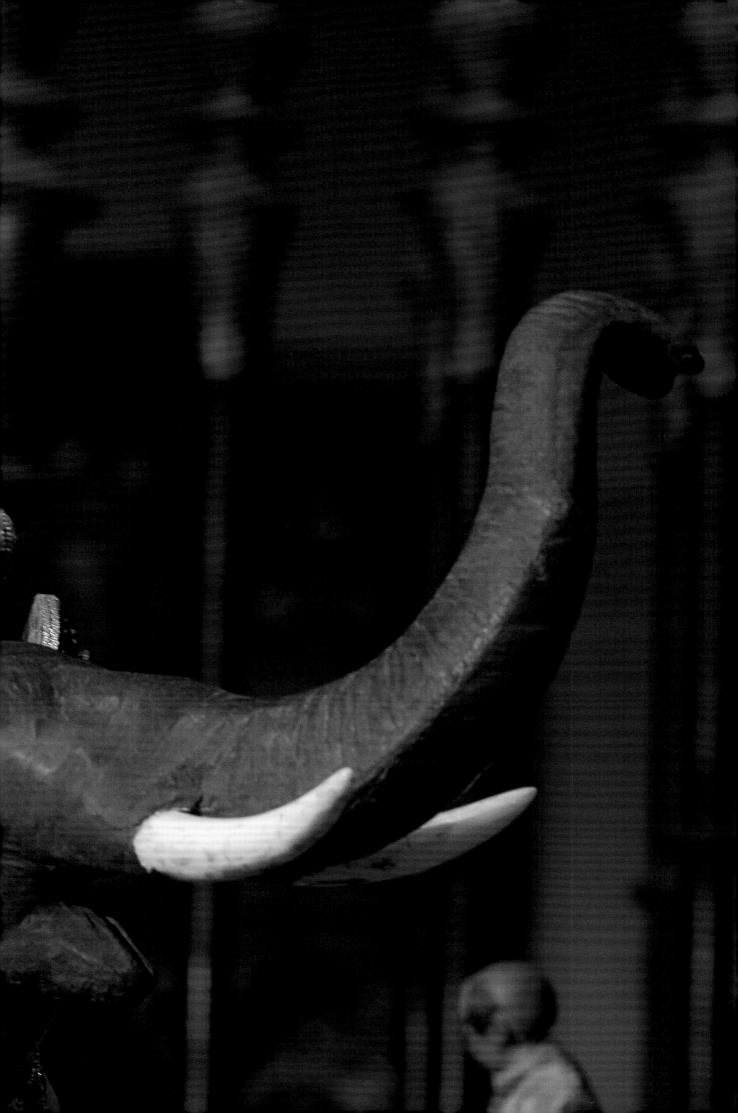

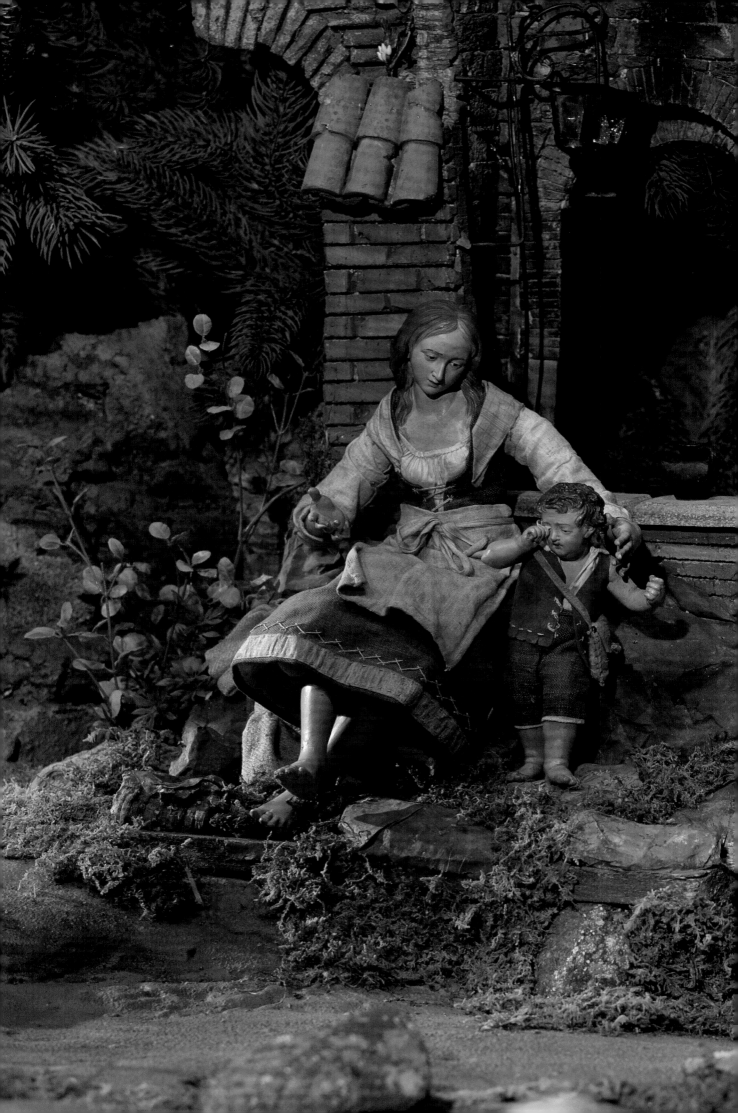

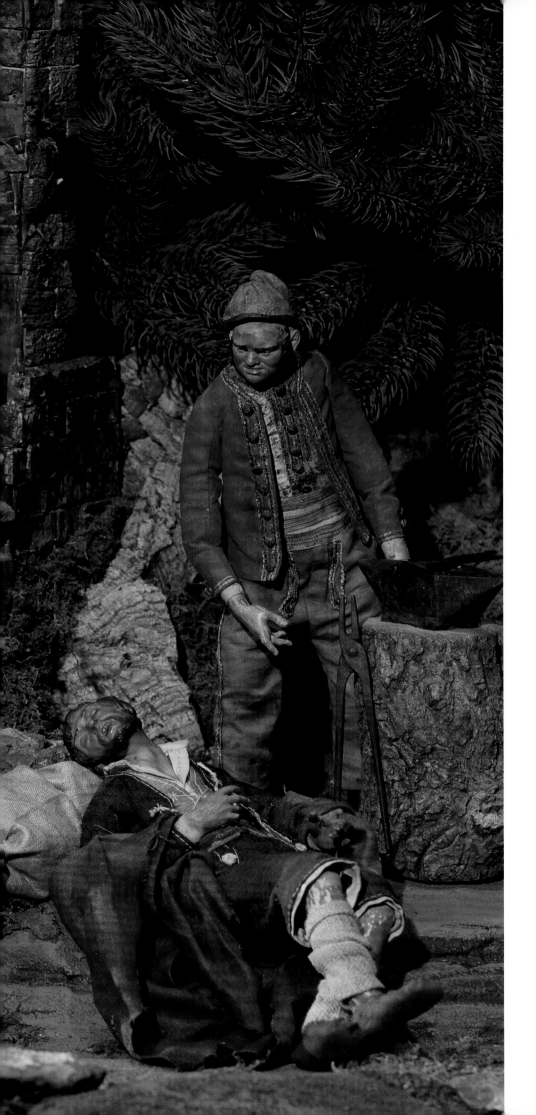

A woman tends her crying child as he rubs his eye and her husband naps on their cottage doorstep. A blacksmith stands beside his anvil and two pairs of tongs.

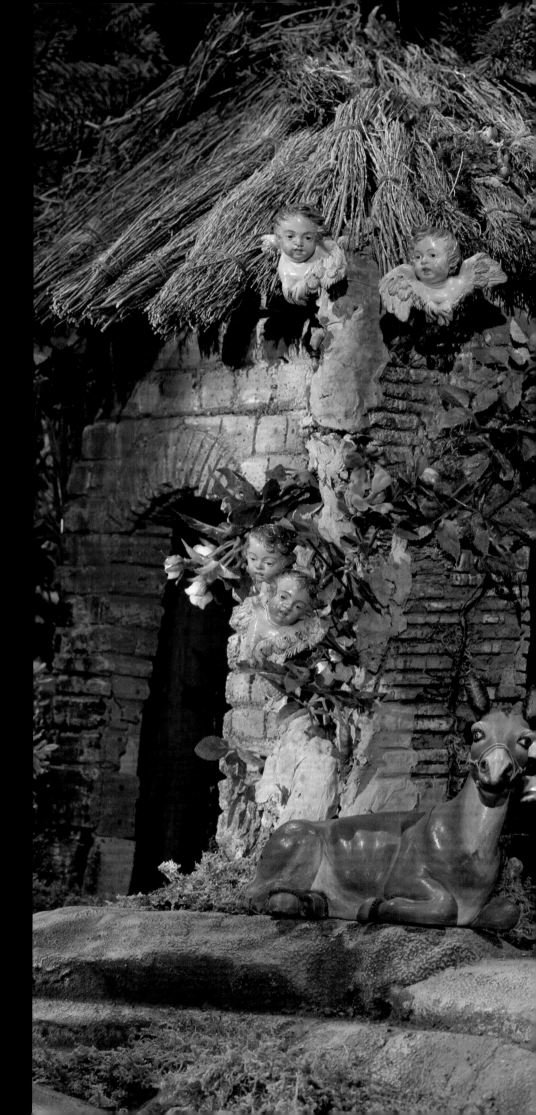

RIGHT AND OVERLEAF
A shepherd eats supper in his thatched cottage while his donkey rests just outside. It is a blessed place with cherubs hovering around the cottage door.

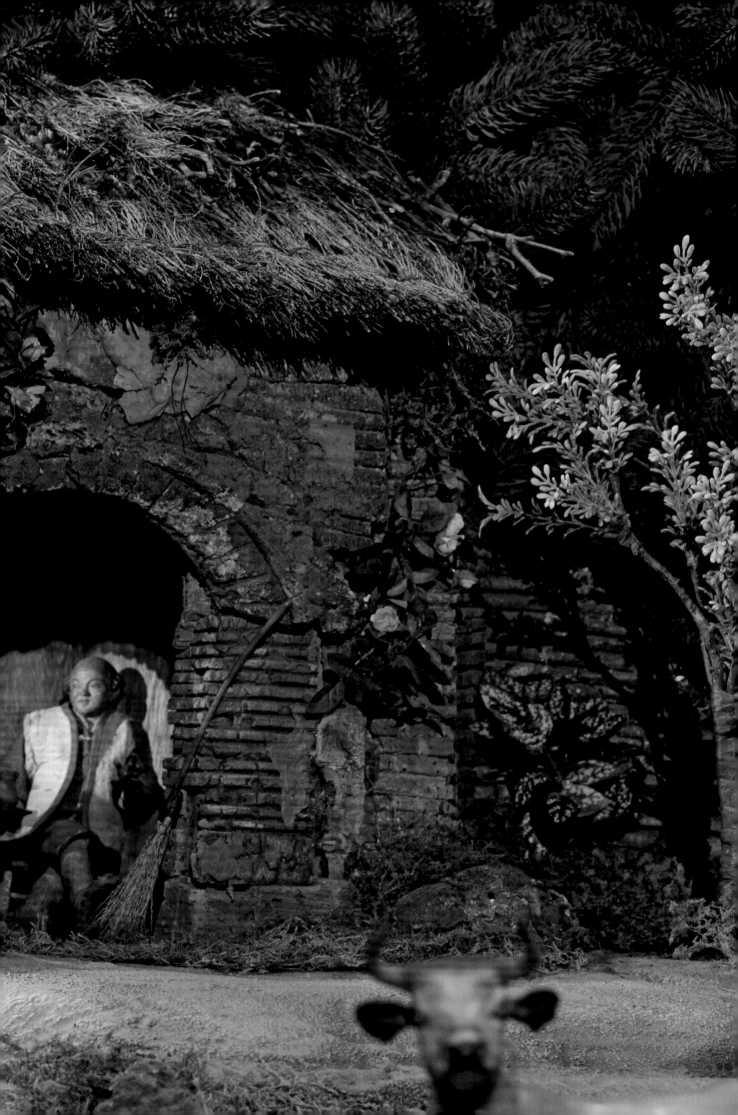

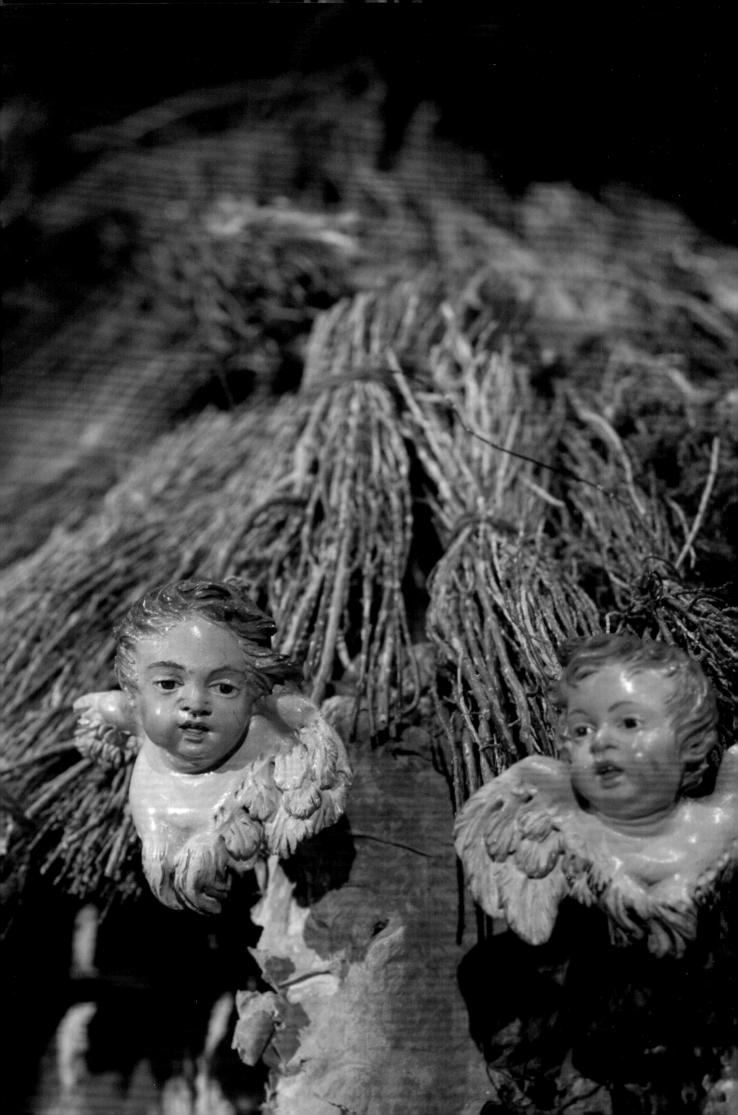

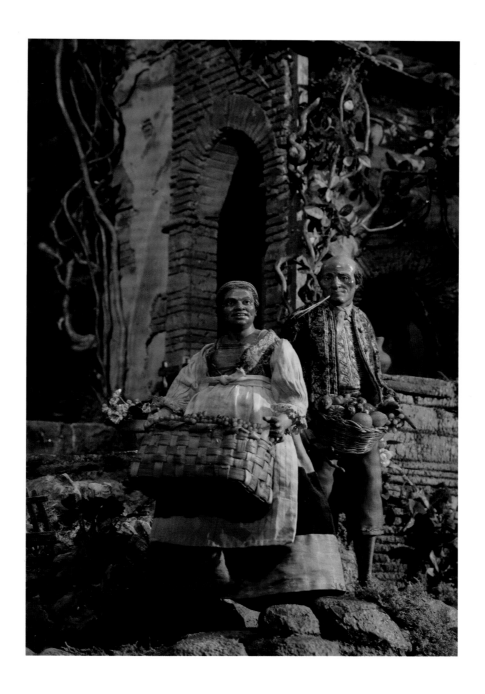

ABOVE

A peasant man and woman bring baskets of yellow and
black grapes and a variety of produce from their farm.
She is attributed to the artist Matteo Bottigliero, a leading
sculptor whose work can be seen in a number of churches
and monasteries.

OVERLEAF

A young man carries bagpipes on his way to join musicians
by a fountain. A king's attendant and a young bull join the
pilgrims to the manger.

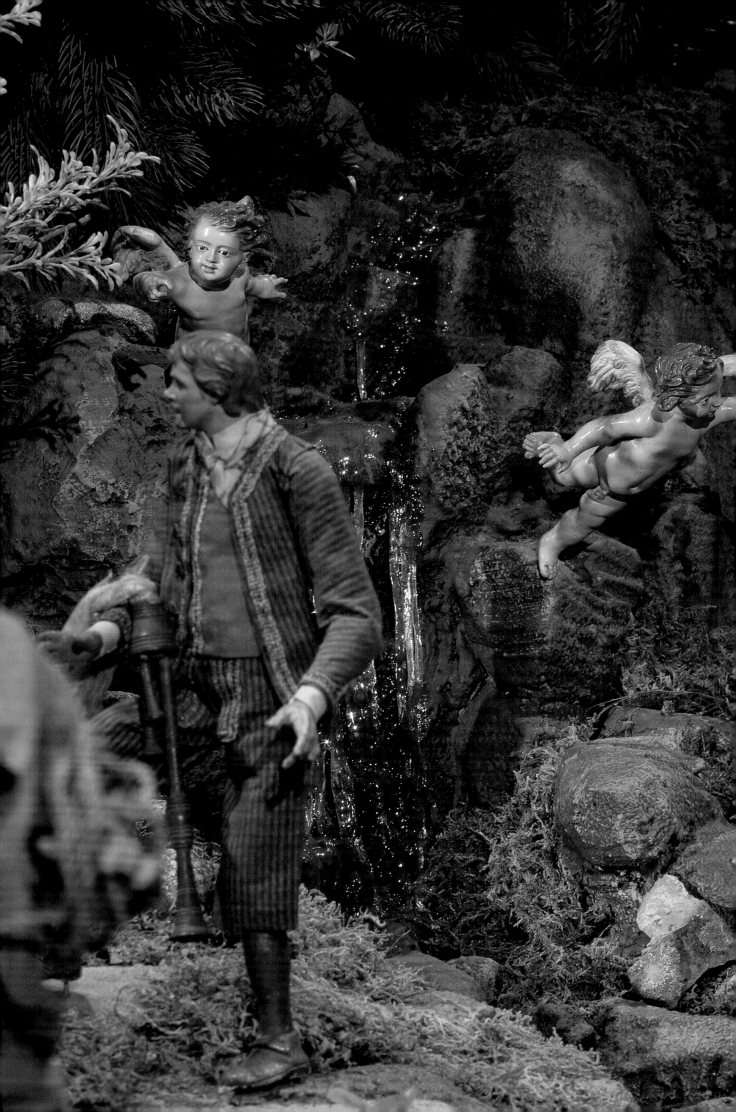

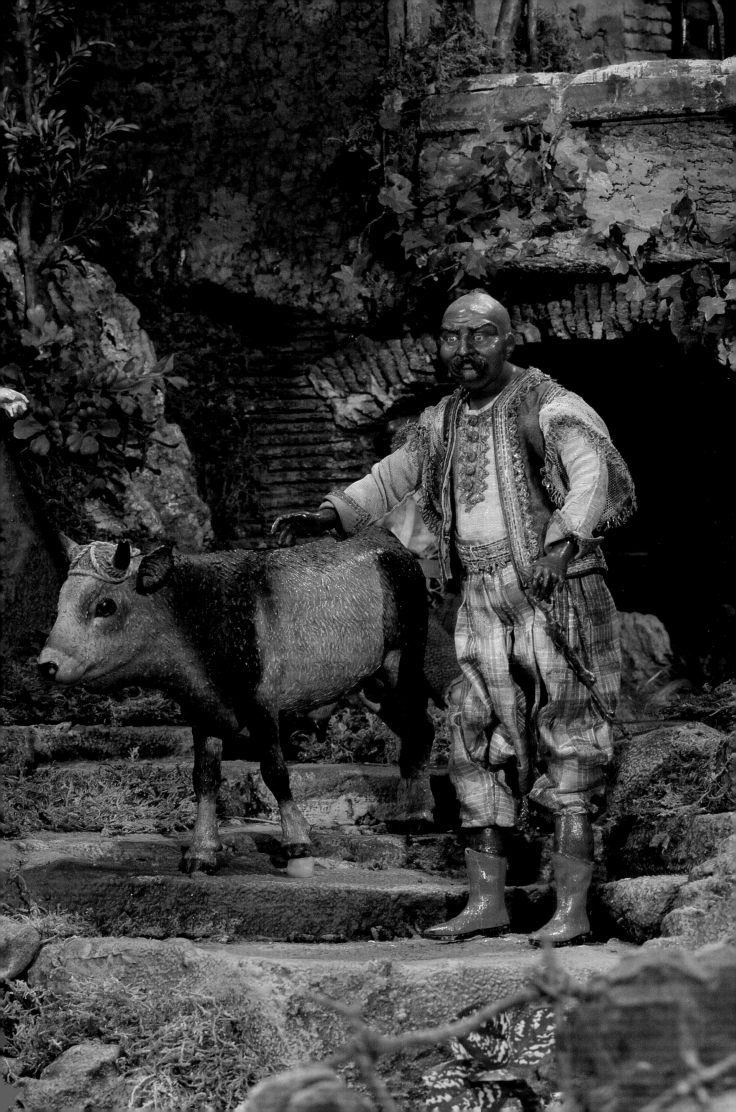

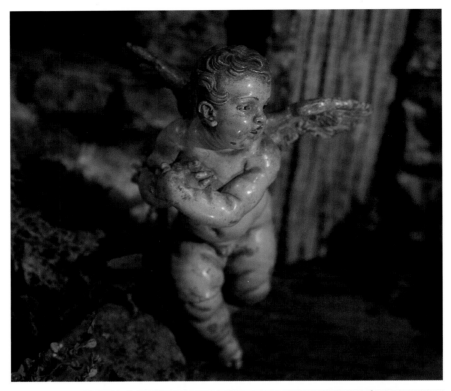

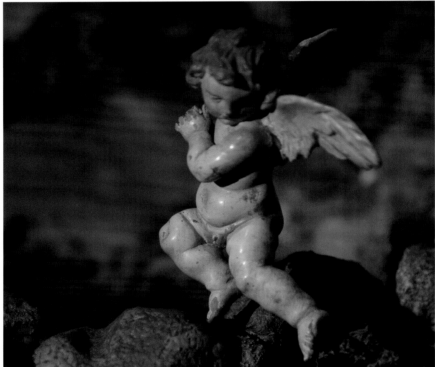

Cherubs in flight and a handsome goat bring a feeling of
heaven and earth to the scene.

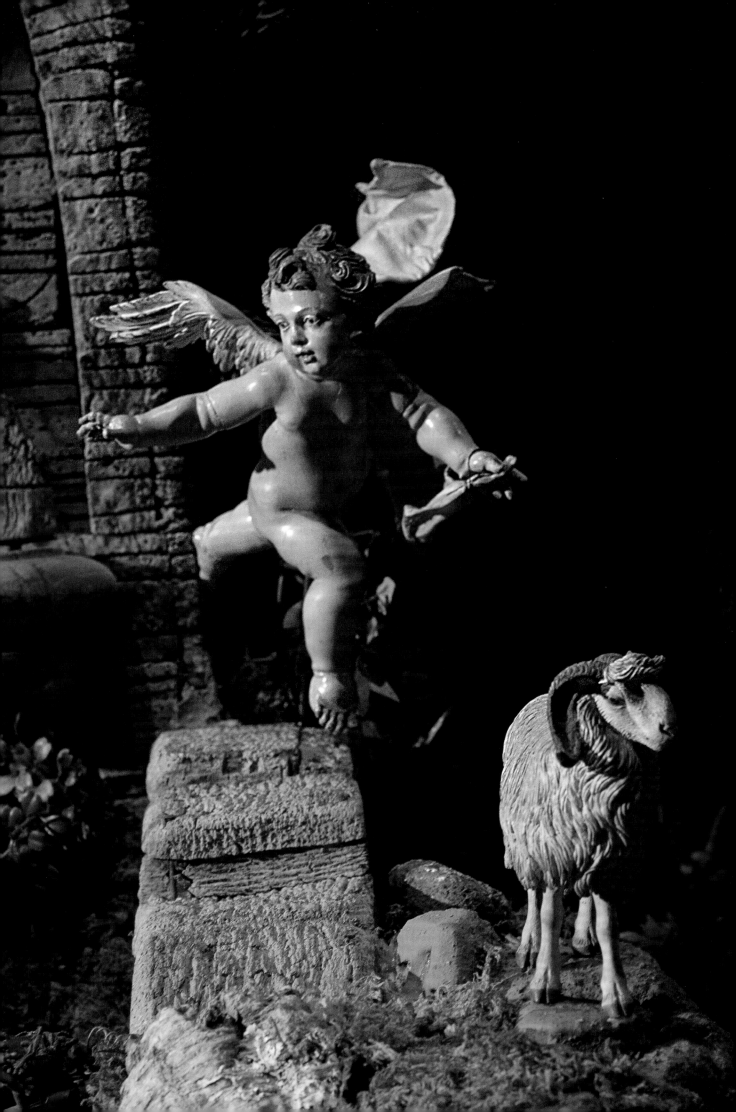

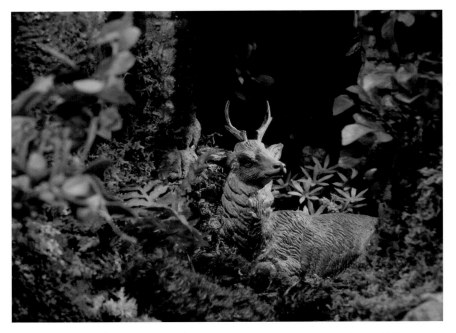

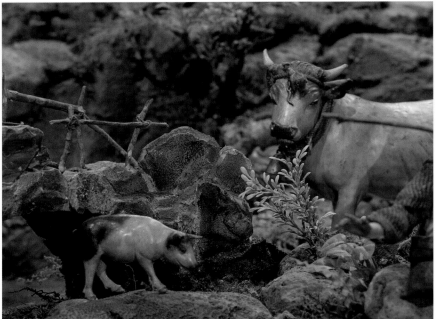

ABOVE
An alert young deer rests in a glade of leafy green.

BELOW
A cow and a young pig come to a rippling stream. The cow
wears a halter with a red tassel and a collar with a bell.

OPPOSITE
A herdsman rests his cows. A watchful cow guards her calf.
They are finely sculpted in terra-cotta and polychromed in
shades of white, brown, and gray.

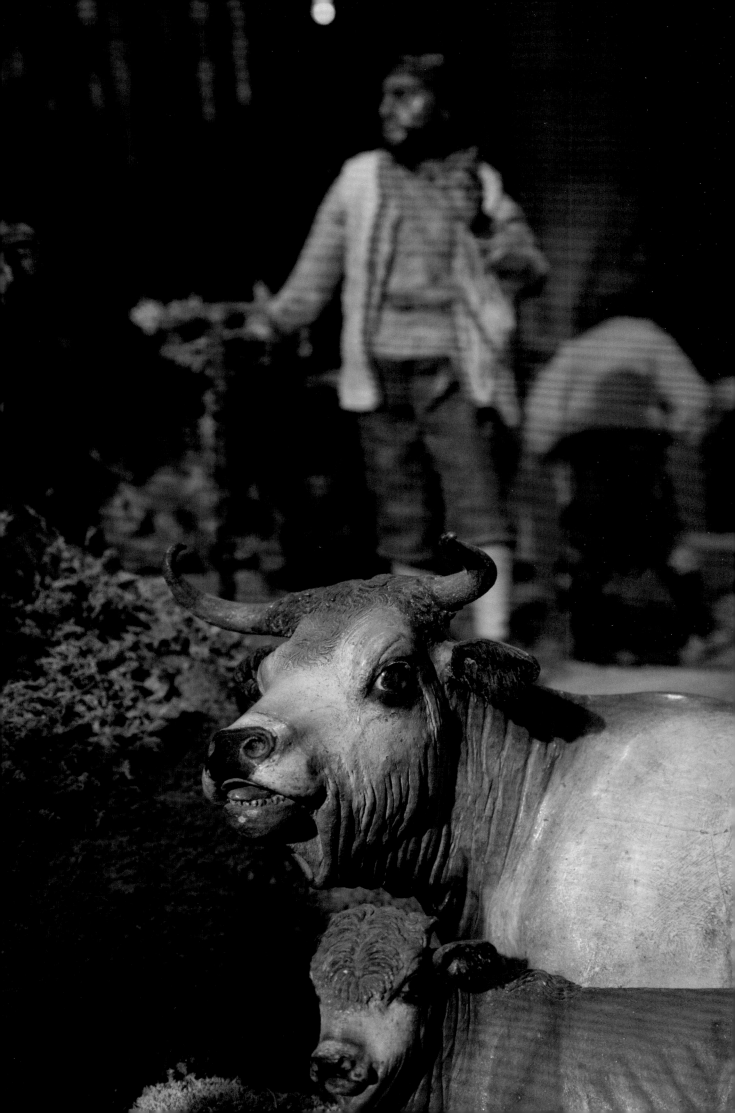

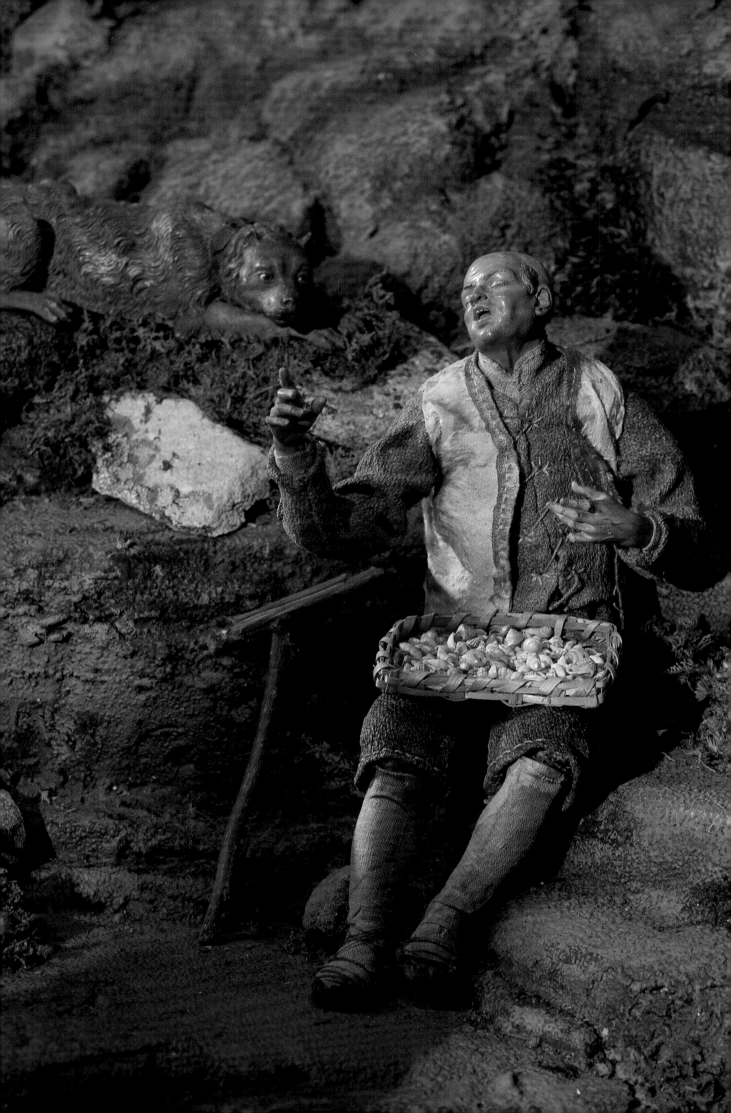

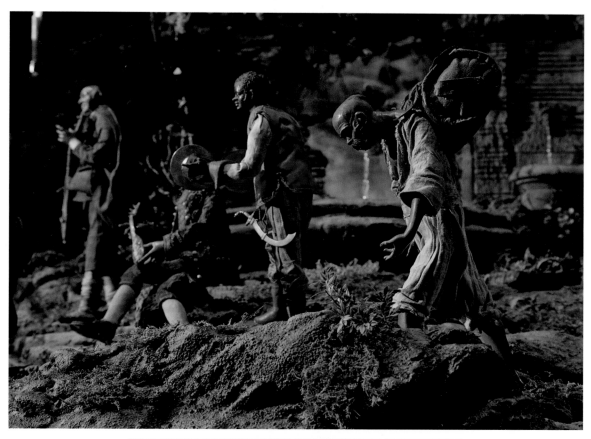

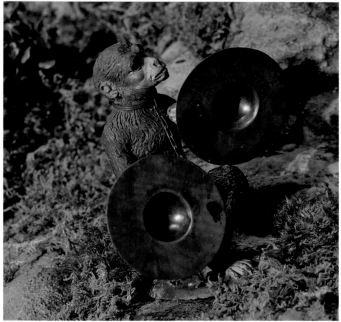

OPPOSITE, ABOVE, AND THE FOLLOWING TWO SPREADS
A blind man selling seashells sits down with his dog to listen
to musicians gathered around a typical Neapolitan fountain. A
man brings his mandolin to join a guitar player and a cymbal
player. A cymbal-playing monkey adds to the joyous sound.

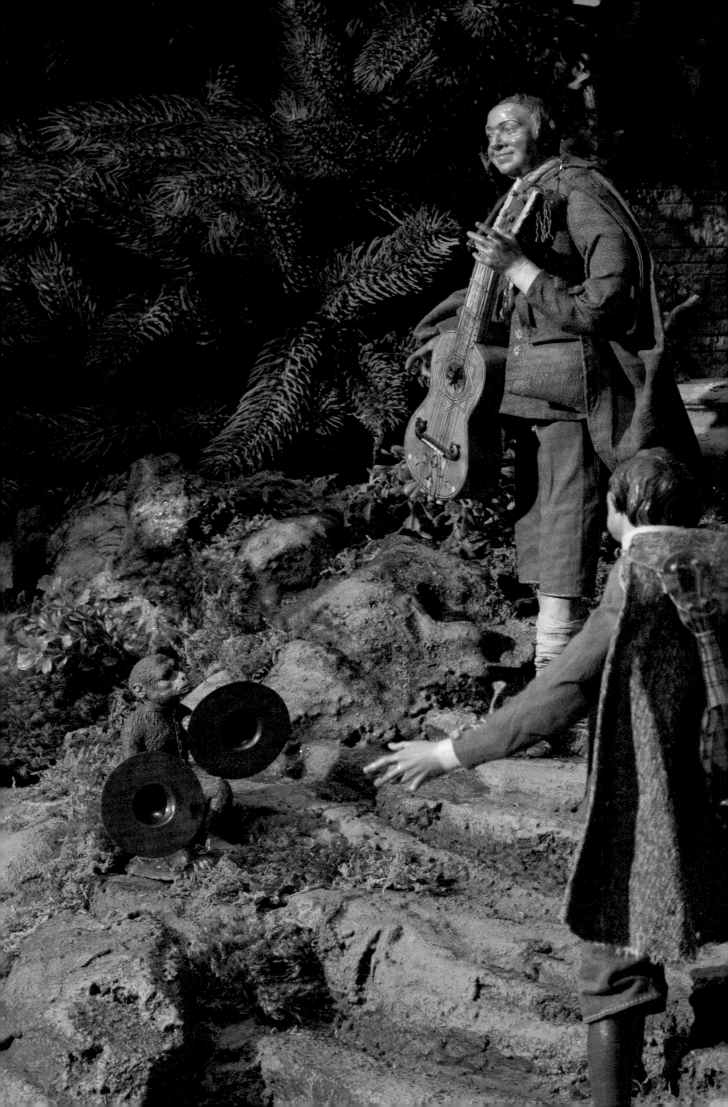

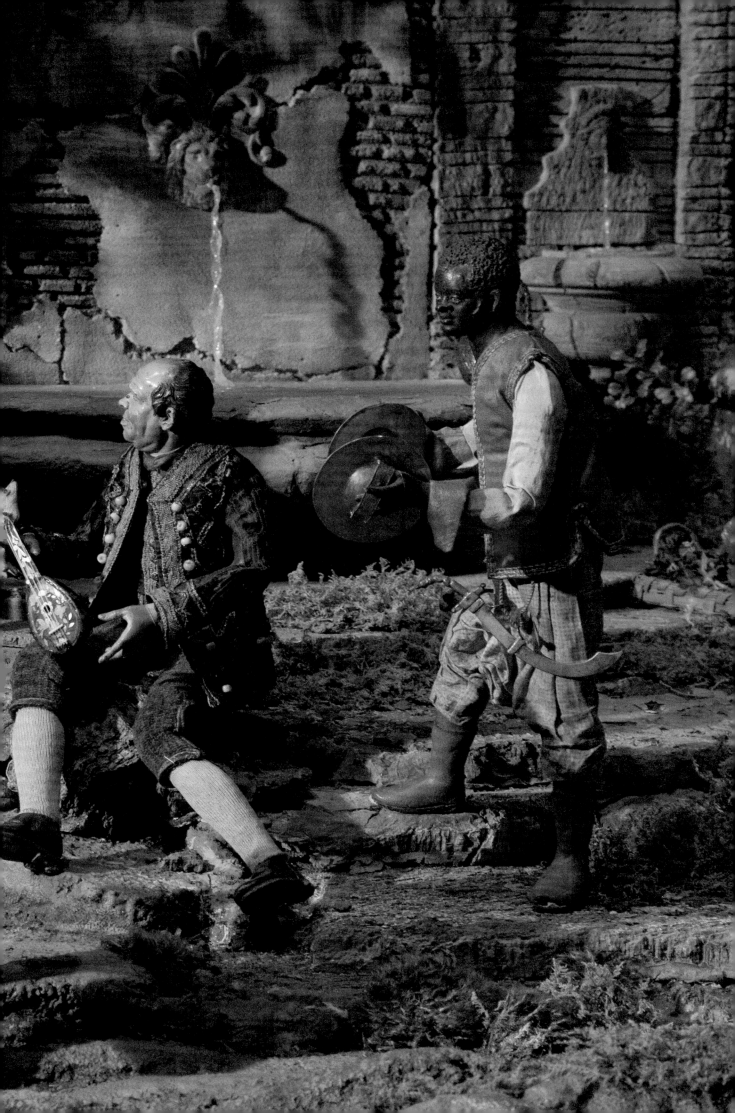

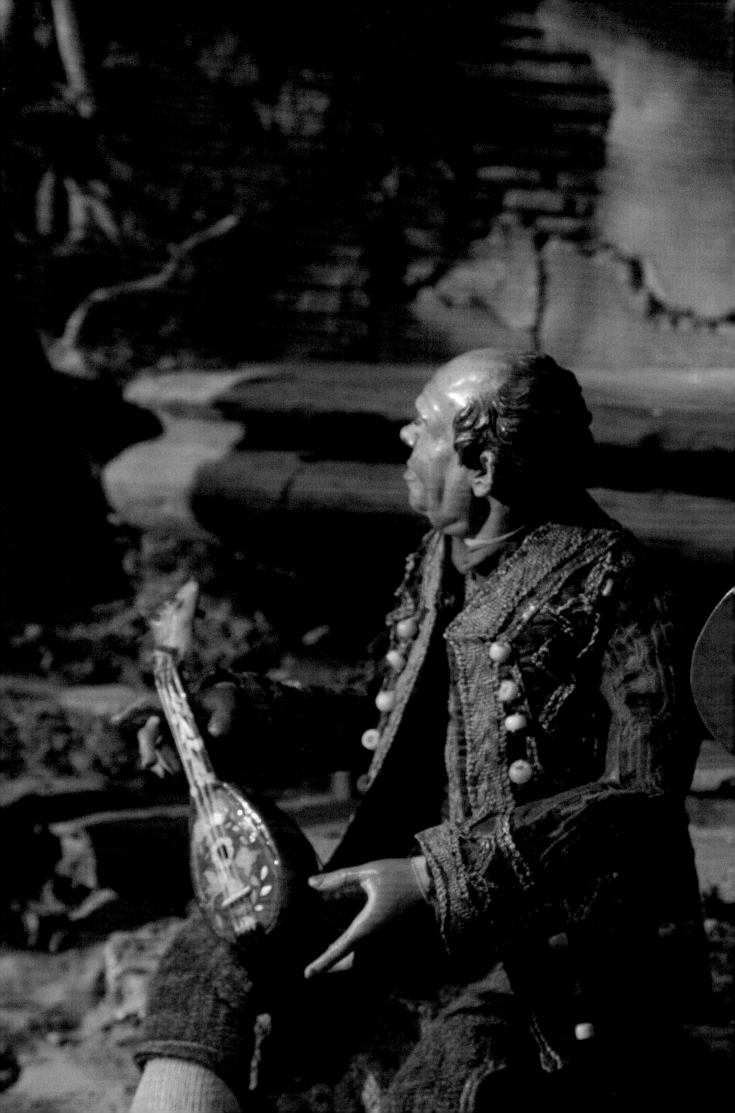

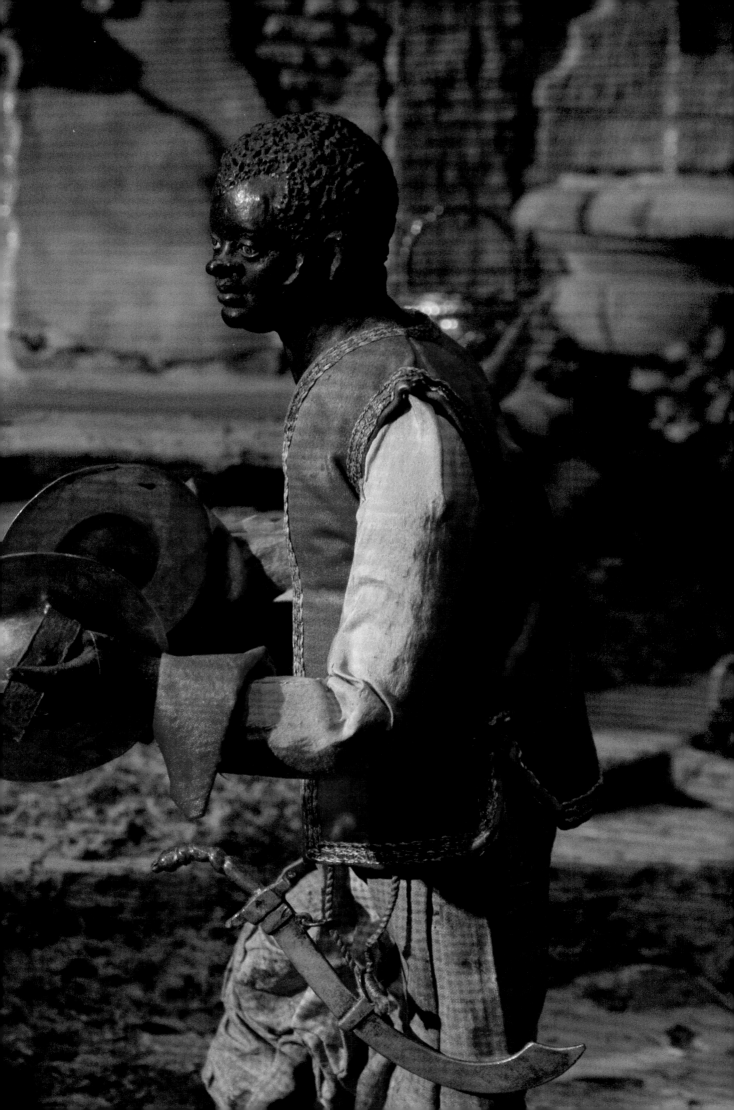

A Glory of ANGELS

IN ANCIENT TEXTS, angels are described as heavenly beings carrying messages from God to man. It was the angel Gabriel who announced to Mary she would give birth to the son of God. Through the ages, the Annunciation has been celebrated by artists who have crafted beautiful human forms—including angel figures with ethereal expressions, a wealth of golden curls, golden diadems, and the finest of robes. Their wings are often a myriad of colors.

In eighteenth-century Naples, leading sculptors were commissioned by noble families to create small figures depicting the Annunciation and the Nativity to celebrate Christmas in their palaces. Angels were the crowning glory of these collections and are still highly prized.

The Loretta Hines Howard collection of eighteenth-century Neapolitan crèche figures at The Metropolitan Museum of Art includes fifty-four magnificent angels and many enchanting cherubs—some forty-seven are attributed to noted sculptors. Each figure is unique. The angels' tiny heads are sculpted of terra-cotta and polychromed in celestial hues. Their cheeks are flushed and their hair seems caught up in the flutter of their wings. Colorful scarves and tunics in rustling antique silks are cinched with belts embroidered in gold and silver thread. Swinging silver-gilt censers, the angels appear to be in flight. In the Museum at Christmastime, this glory of angels hovers in the branches of a giant Christmas tree, adoring and protecting the Christ Child in the crèche below.

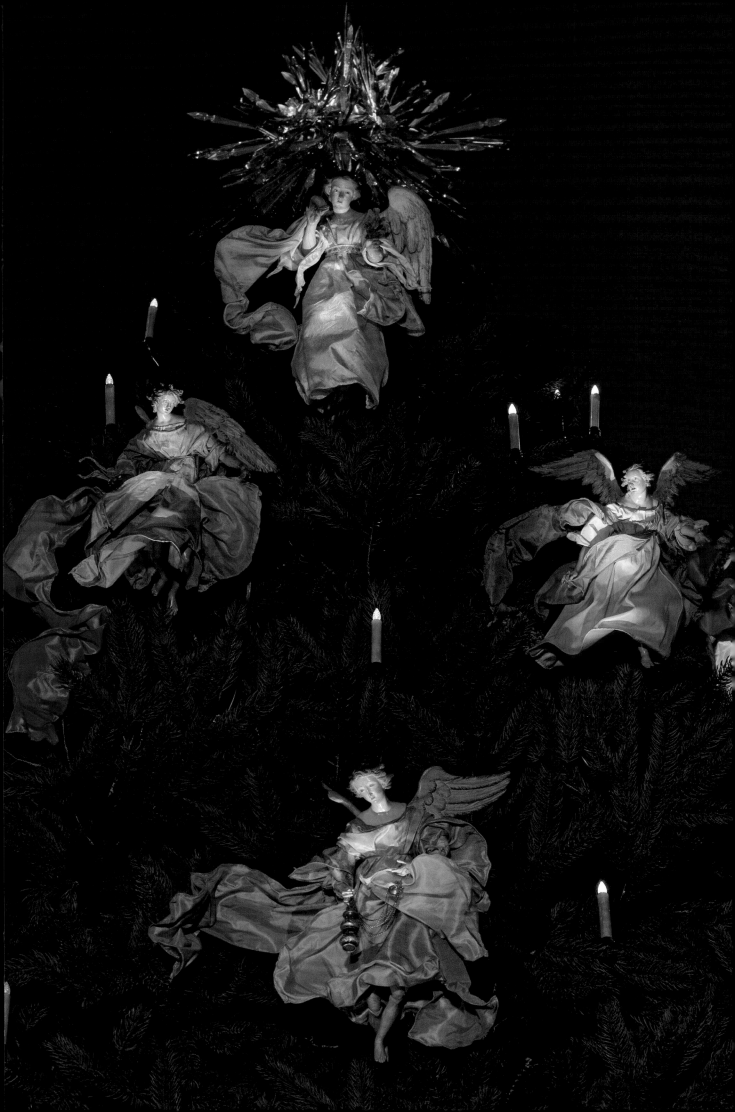

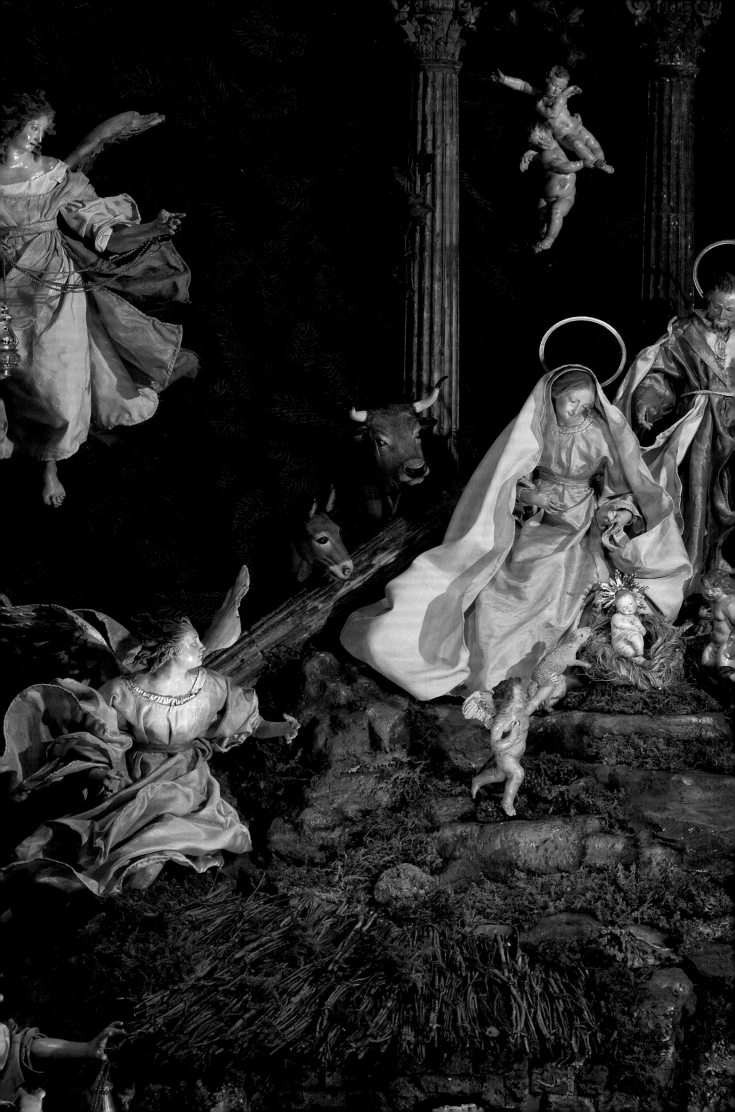

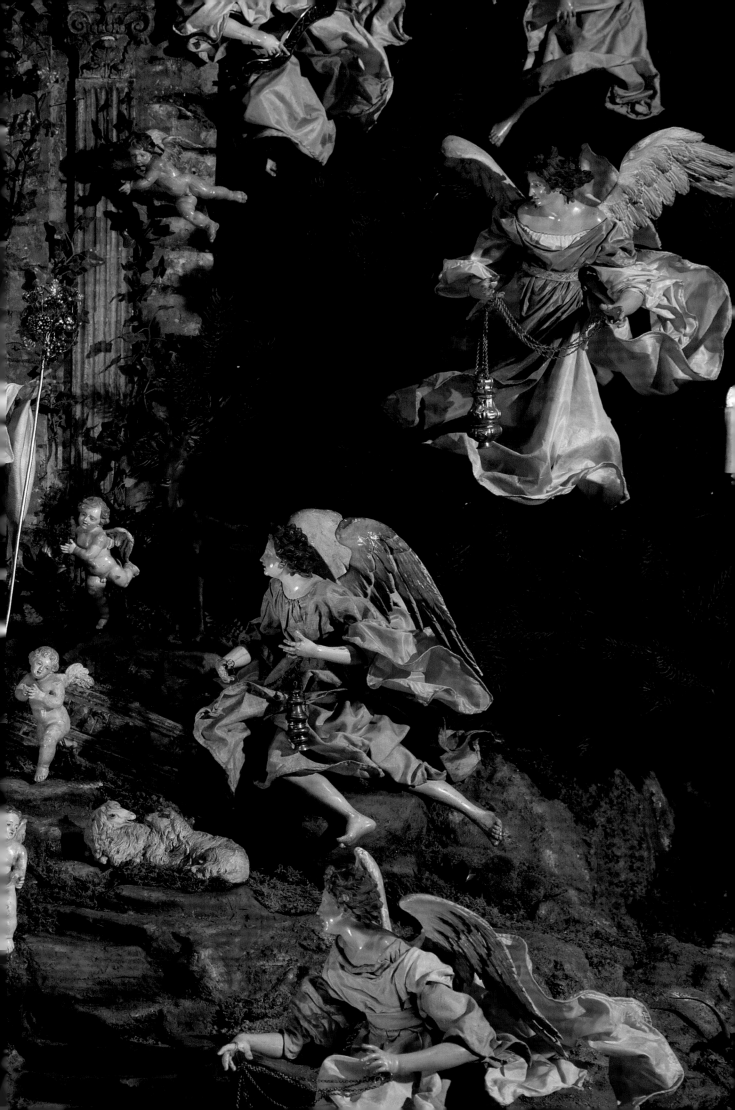

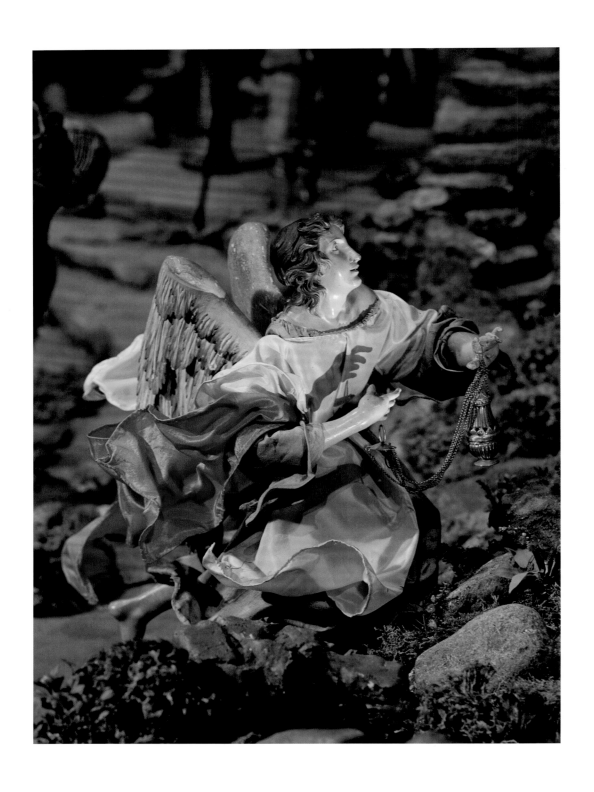

ABOVE
This angel is attributed to Lorenzo Mosca.

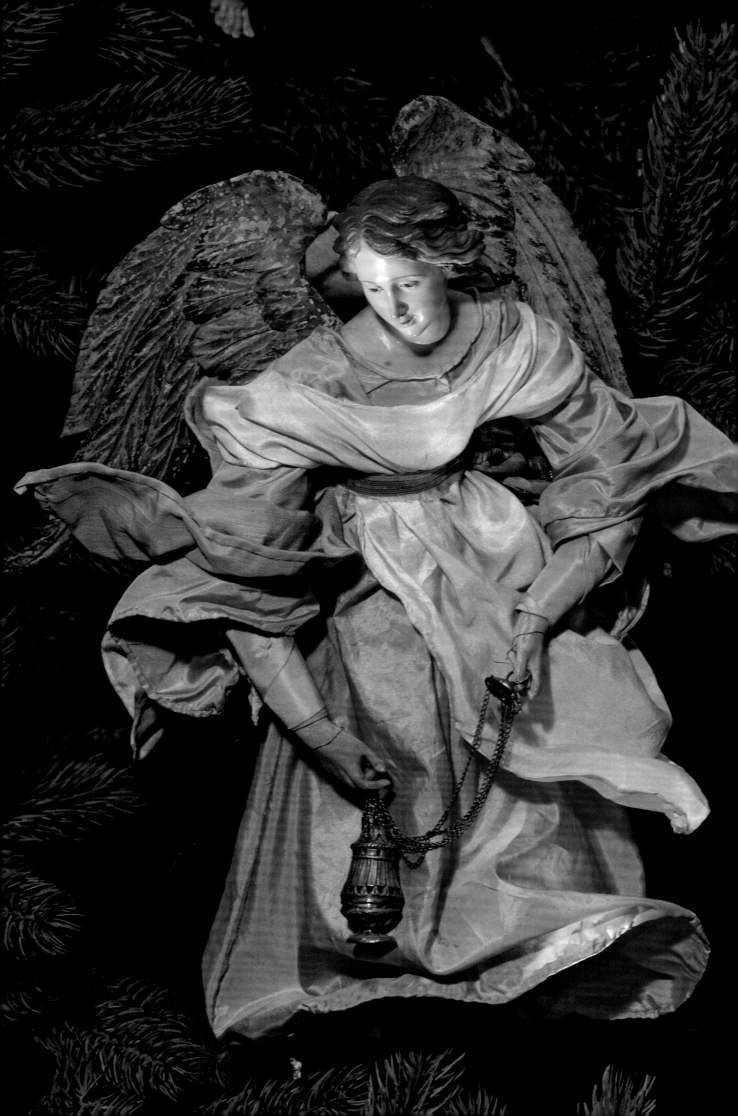

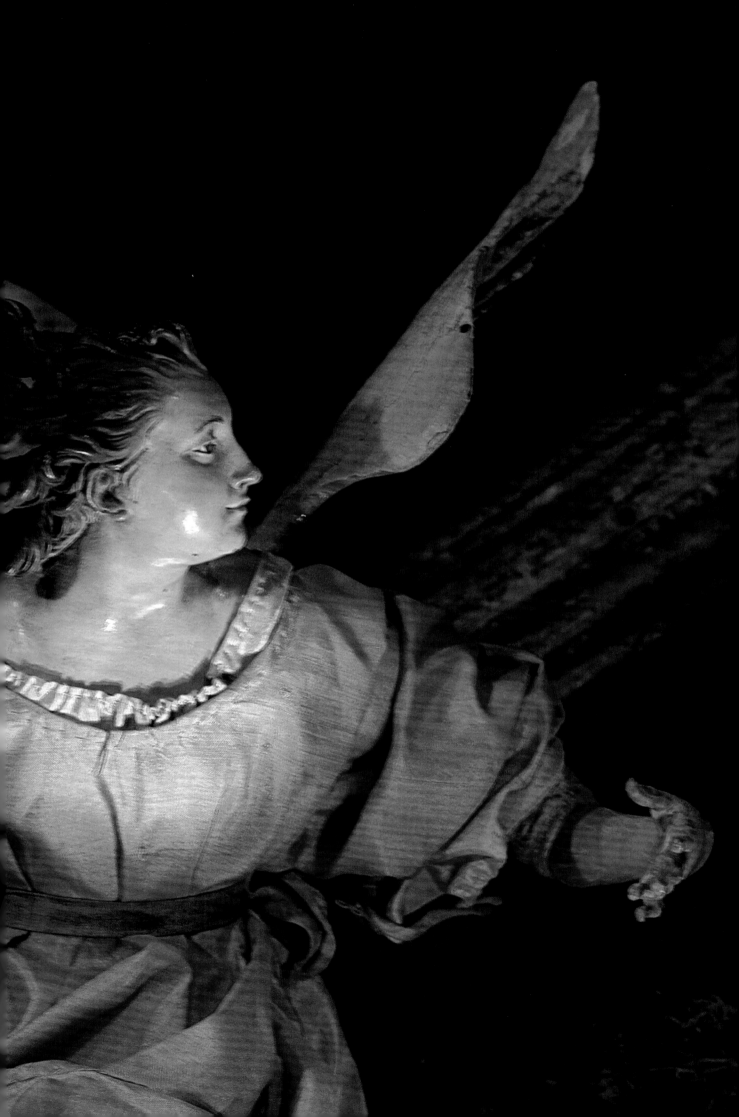

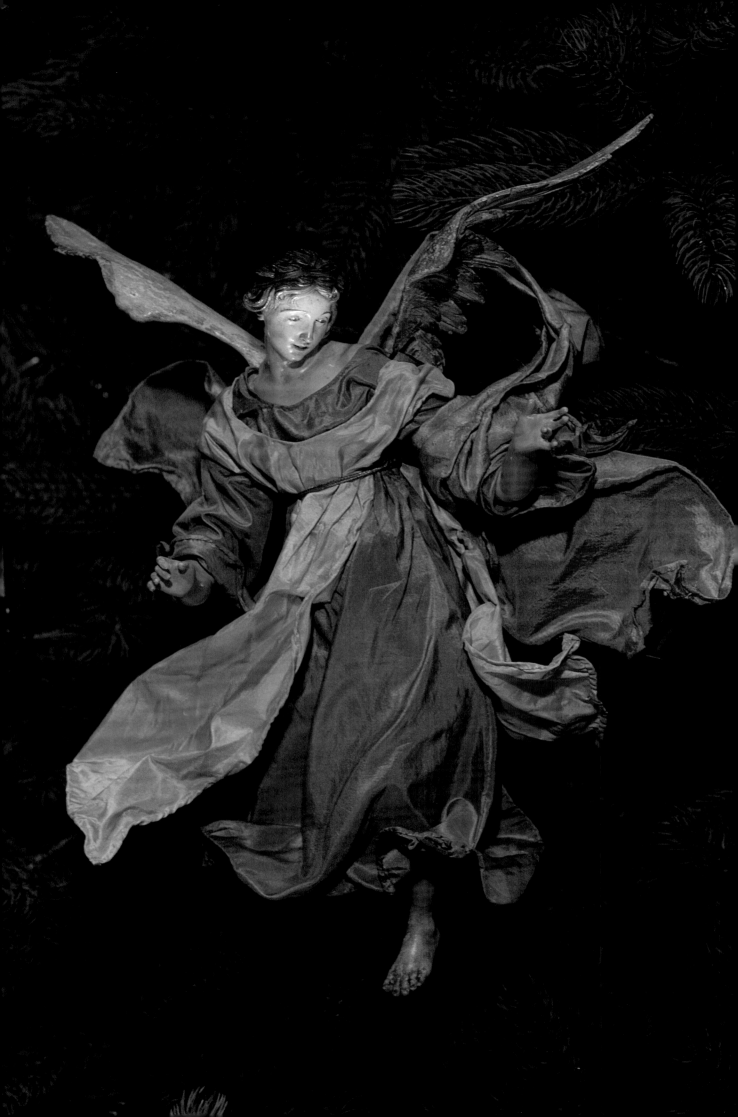

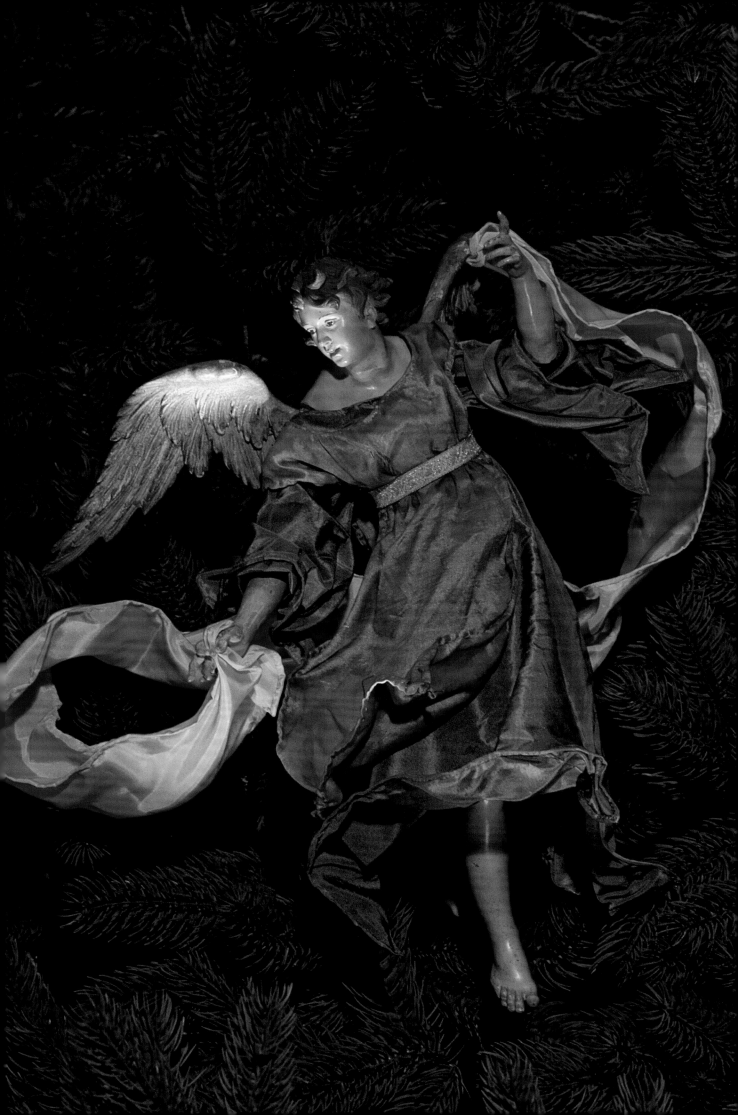

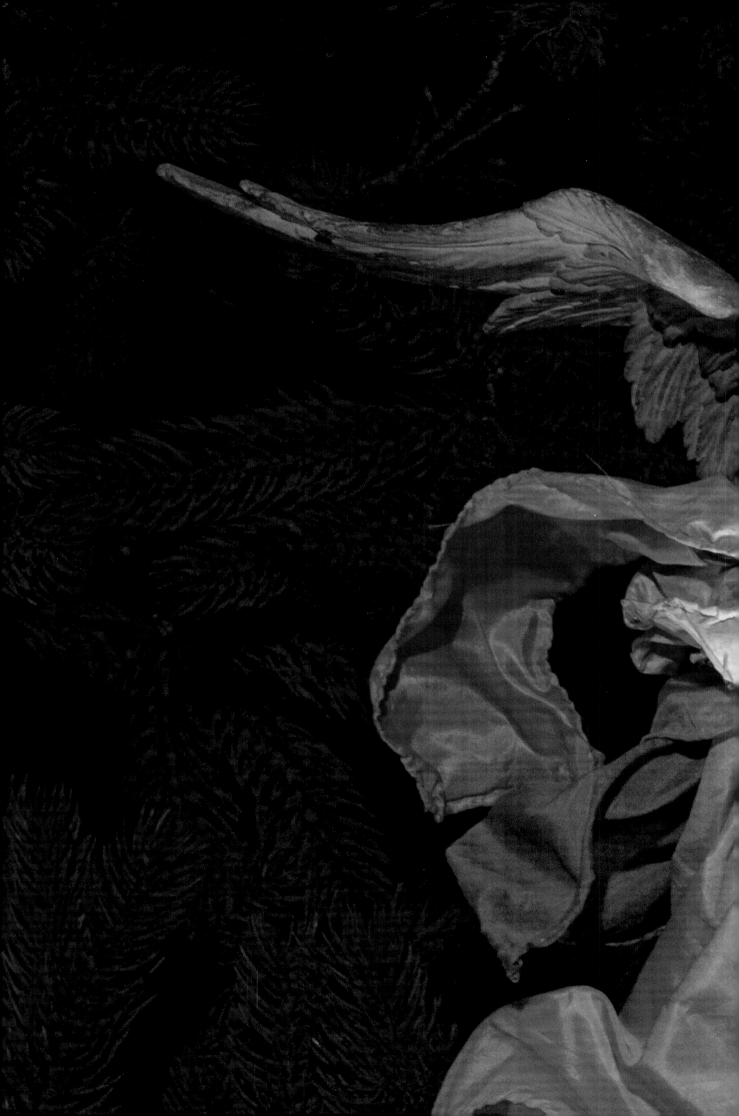

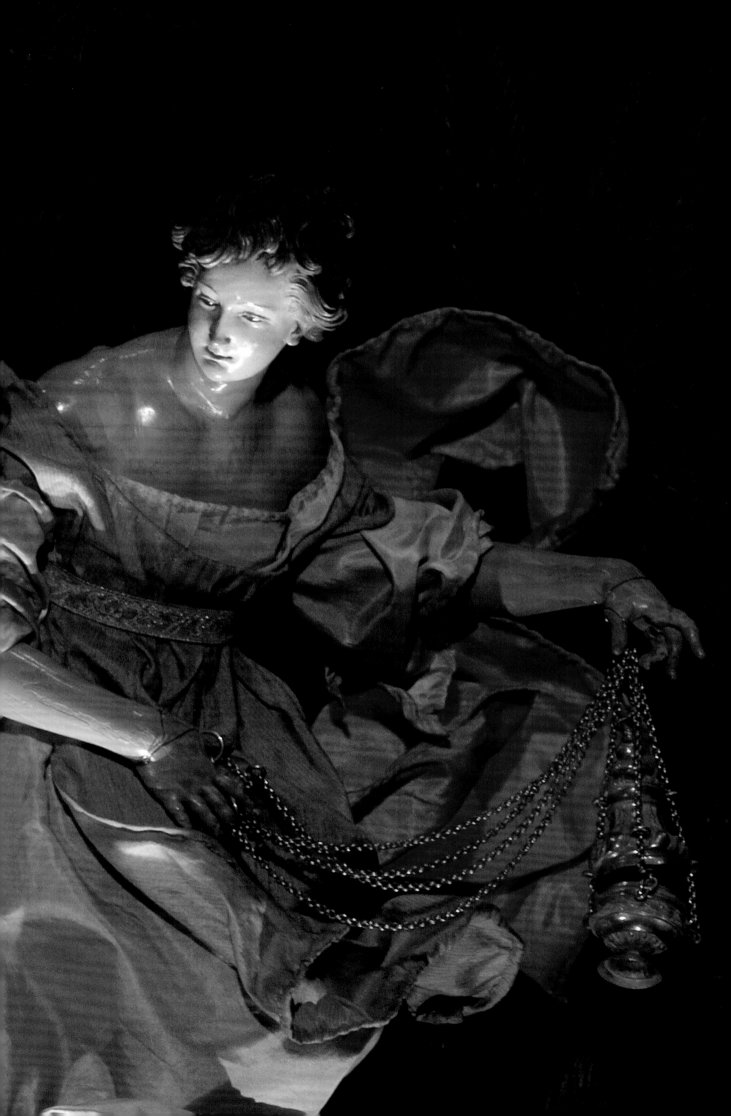

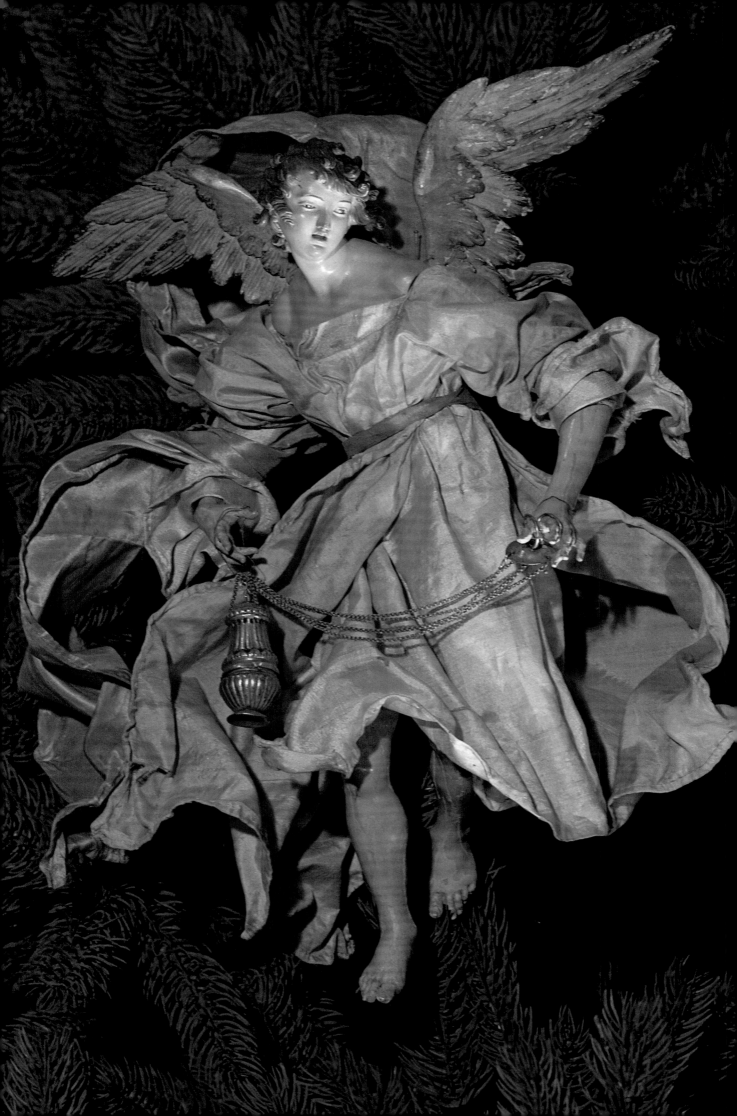

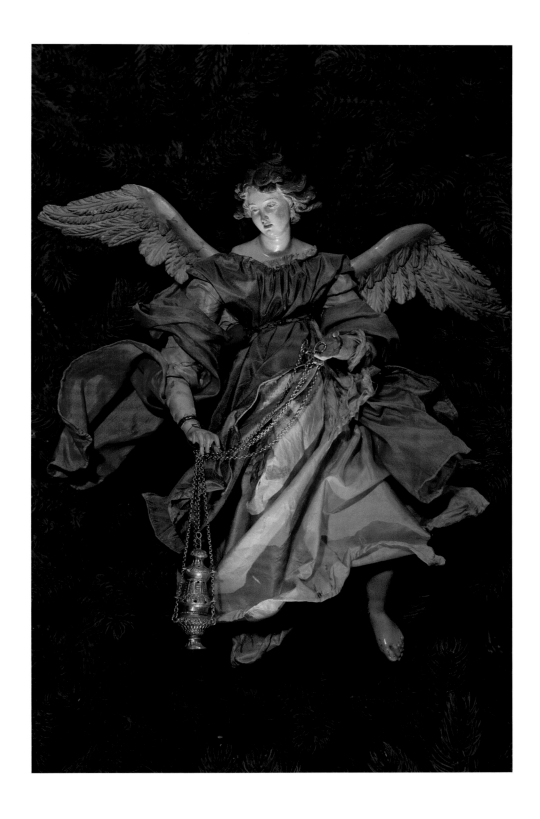

PRECEDING SPREAD AND OPPOSITE
These angels are attributed to Giuseppe Sanmartino.

OVERLEAF
The upper angel is attributed to Salvatore di Franco.

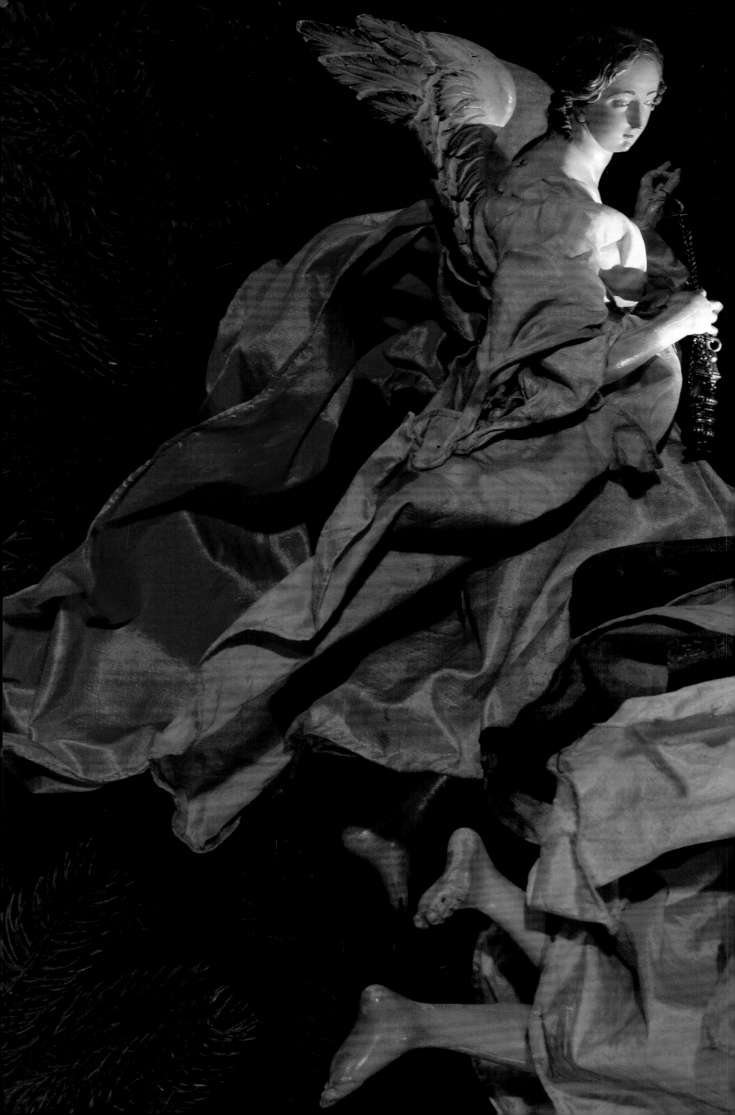

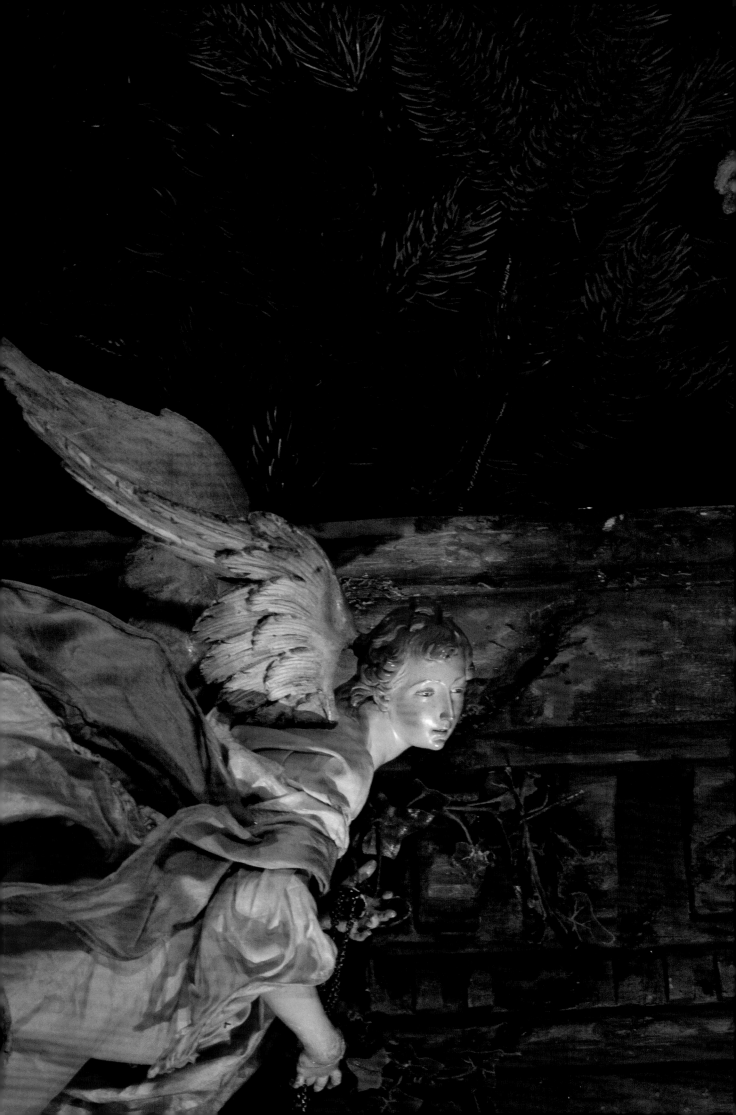

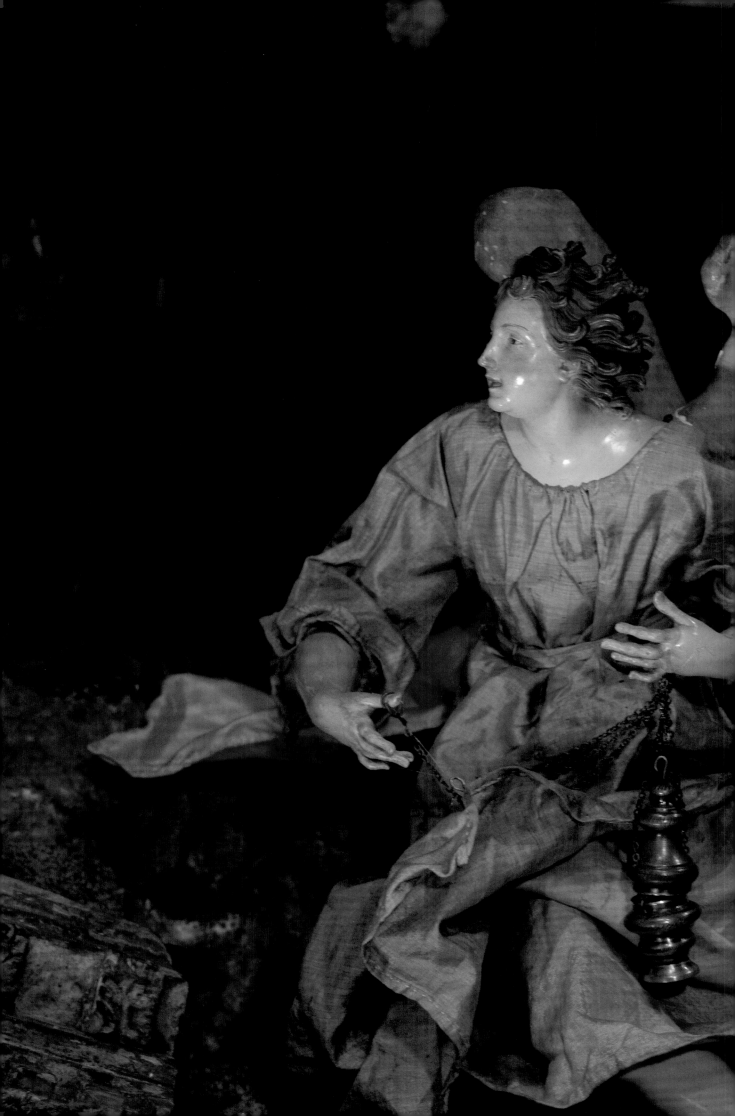

LEFT
This angel is attributed to
Giuseppe Gori.

OVERLEAF
The angel on the right is
attributed to Nicola Ingaldi.

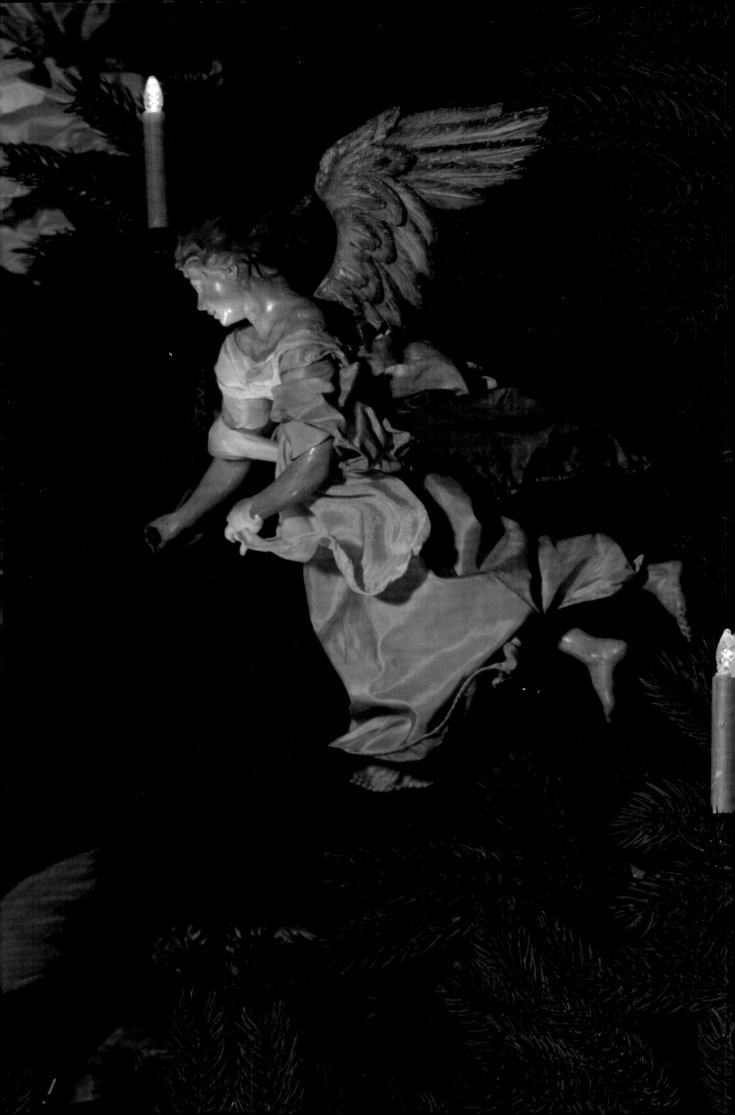

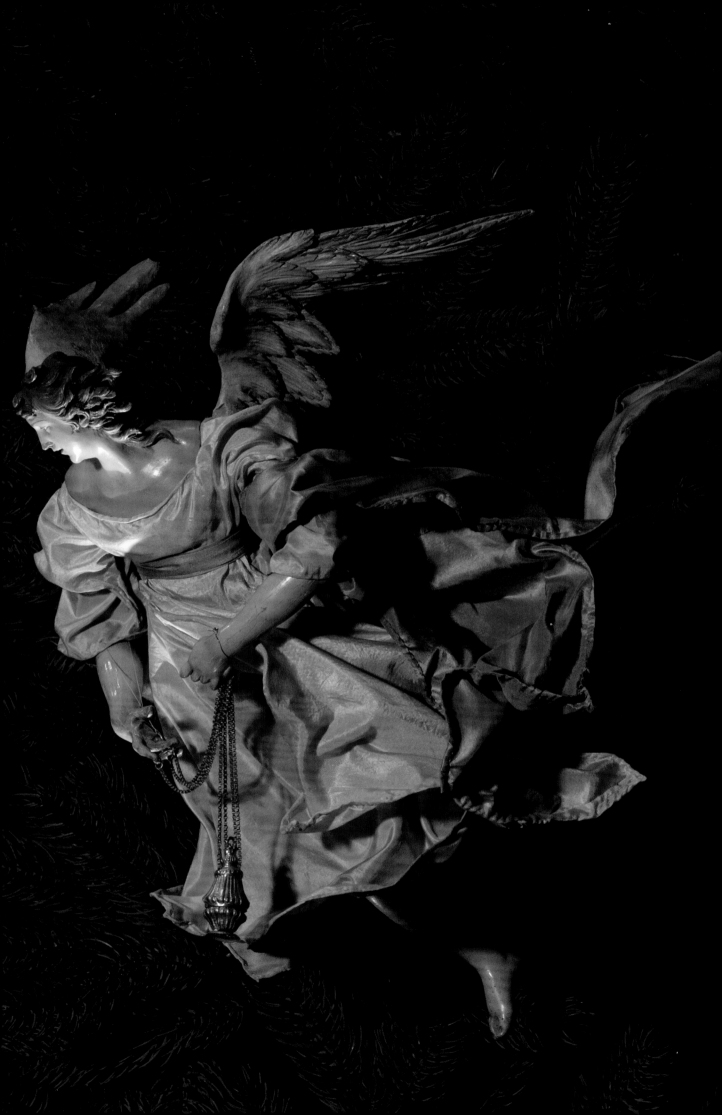

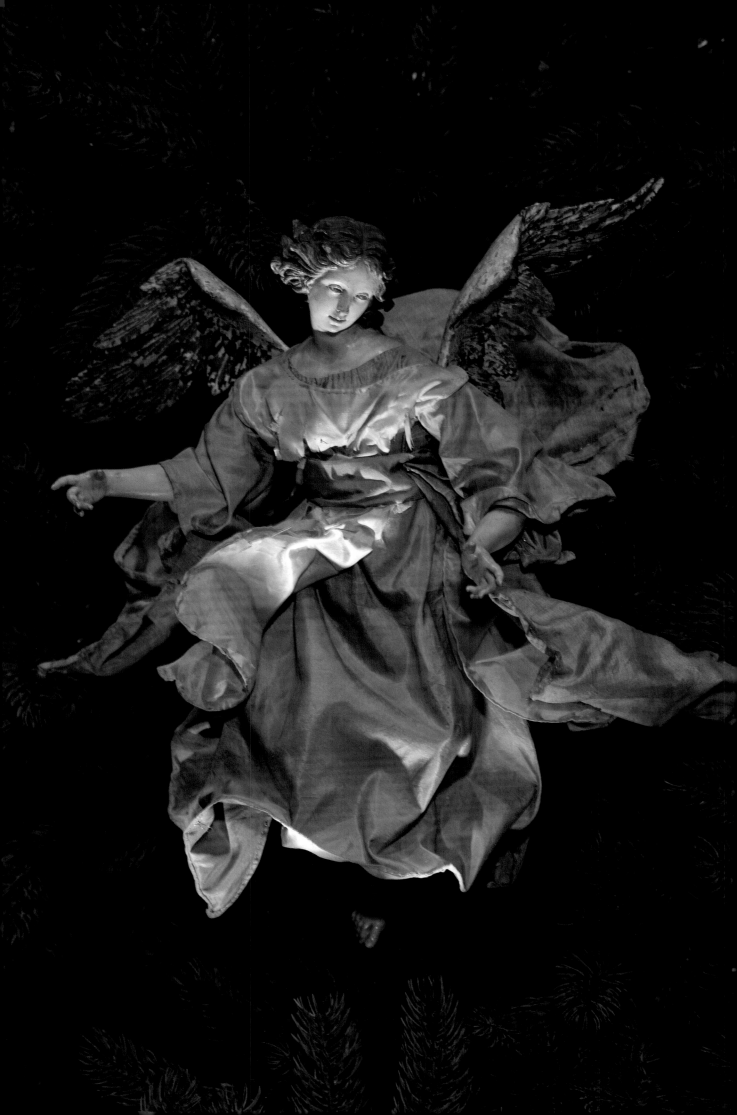

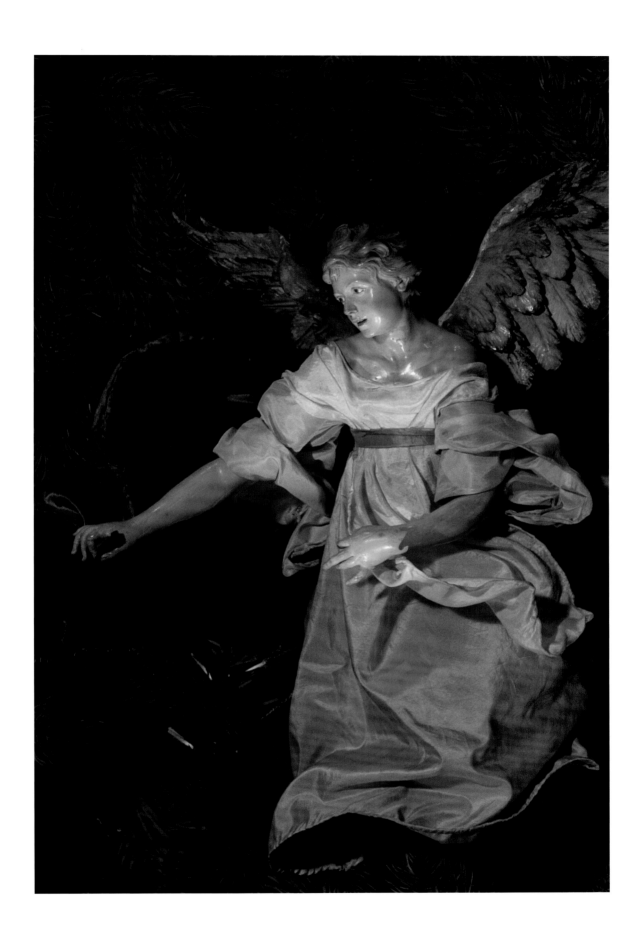

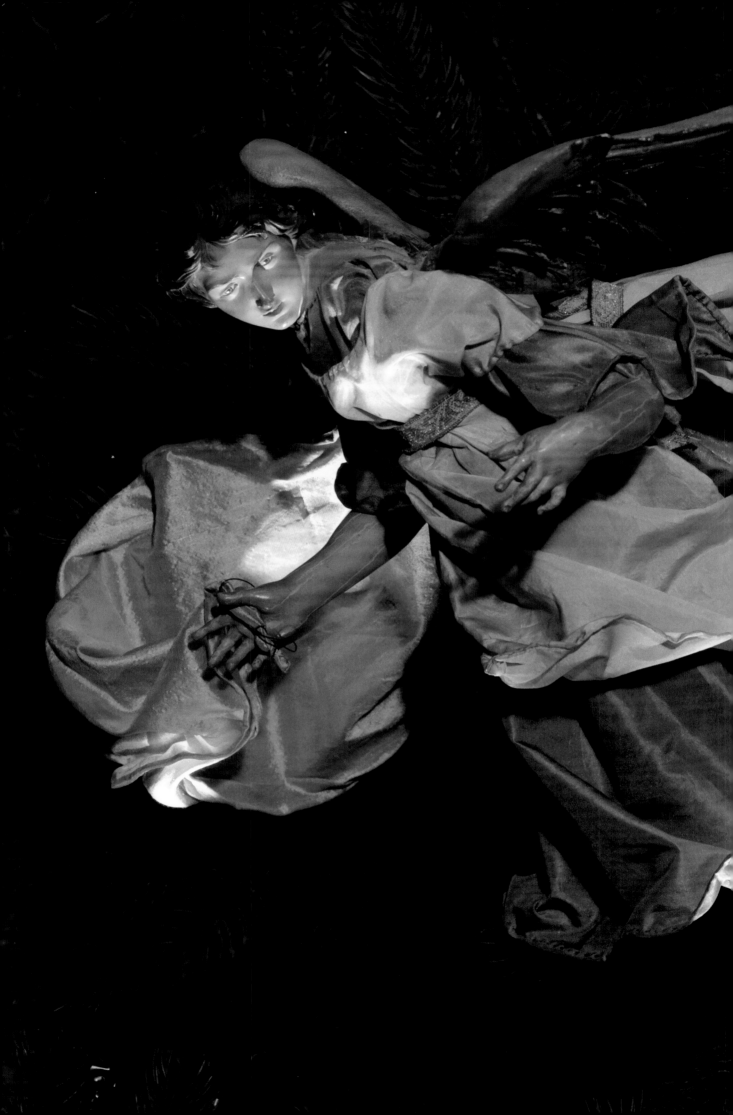

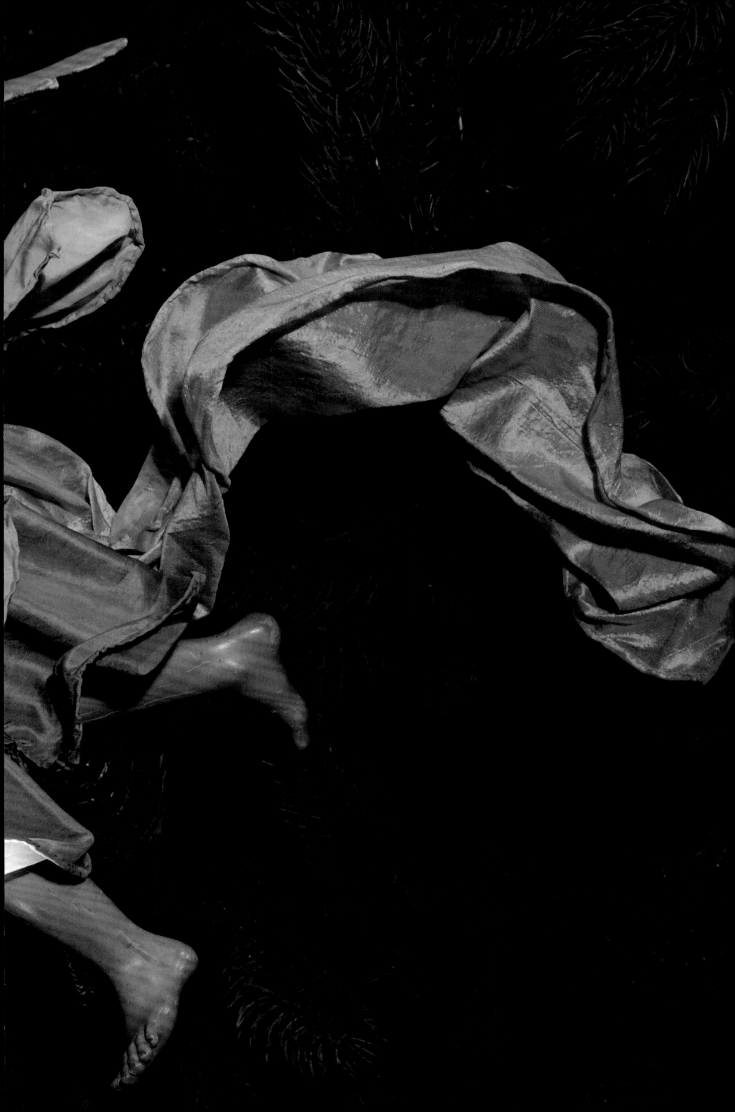

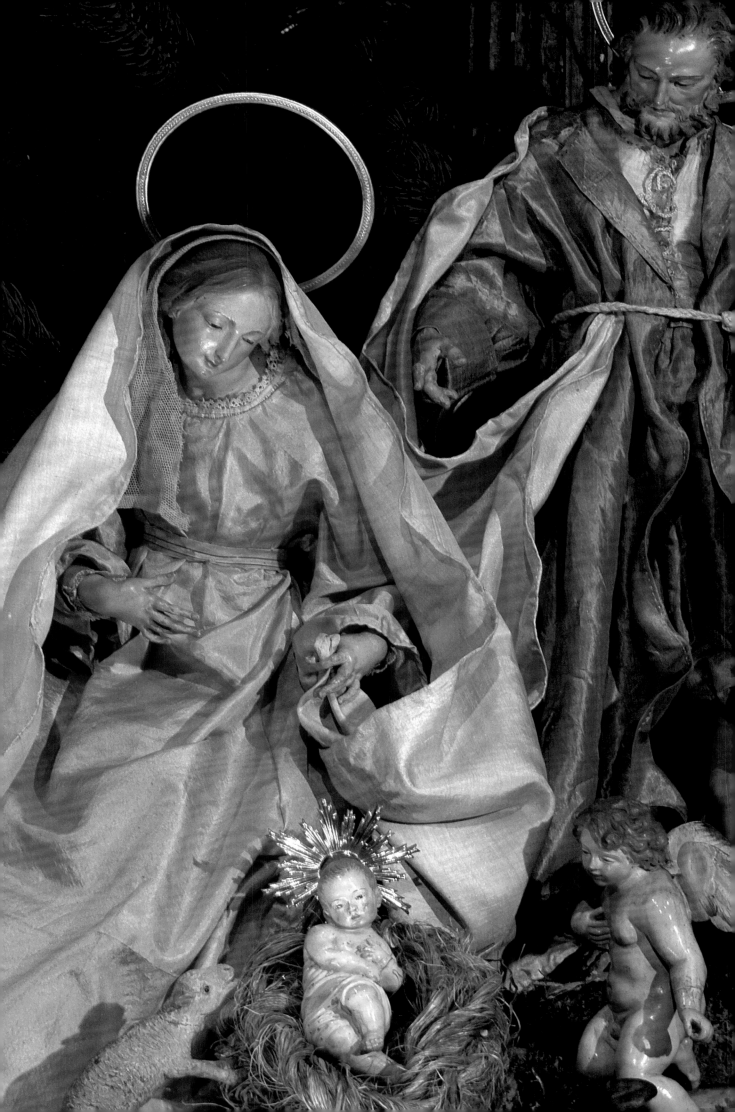

The ANGEL TREE *and the* LORETTA HINES HOWARD CRÈCHE *Collection*

LORETTA HINES HOWARD was born with an eye for beauty and art. On family trips to Europe, she saw magnificent art in churches, museums, and palaces, and religious art from all over the world became a lifelong passion. In 1924, as a wedding present, her mother gave her a small eighteenth-century Neapolitan crèche grouping of three figures—Mary, Joseph, and the Christ Child. She began to look for more figures to add to the Nativity scene on her wedding trip to Europe. Thus her collecting began.

The Howard home was a center for the display of religious art and her own paintings—she was a student of the American painter Robert Henri. Family and friends particularly enjoyed the way she displayed her collections at Christmastime. Many of her major acquisitions are now in the permanent collection of the Metropolitan Museum.

In 1952, Francis Henry Taylor, who was the Museum's director, told Loretta Howard about an extraordinary eighteenth-century Neapolitan crèche, called *The Adoration of Angels*, he had seen exhibited in Paris. It belonged to Eugenio Catello, whose family museum of crèche figures in Naples was world famous. After several years of negotiation, she was able to purchase the collection. In the family Christmas tree, she placed the angels soaring to the top and the colorful pilgrims on their way to the manger in the lower branches. The effect was spectacular. Combining the traditional Northern European Christmas tree with the crèche figures from Southern Italy was an exciting change from the way the Neapolitans displayed their crèches in architectural settings.

In 1957, James J. Rorimer, then director of the Museum, asked Mrs. Howard to bring her Christmas celebration to the Museum's Great Hall for all the world to enjoy, and in 1964 she gave her collection to the Museum, where it soon found a home in the Medieval Hall during the Christmas season. For Loretta Howard, the annual re-creation of the Angel Tree was an act of love and religious devotion. Artist Enrique Espinoza created the dazzling star at the top of the tree, and for many years worked with Mrs. Howard, along with Howard family members and friends, as she added to the collection and arranged the figures in new groupings. Her daughter, Linn Howard, and granddaughter, Andrea, continue her work, acquiring new figures and objects and redesigning the landscape to accommodate them. The collection now numbers some three hundred figures. Each year there is something new to discover.

During the exhibition of the crèche, the Museum schedules daily lightings with music. In the darkness of the Medieval Hall, to the strains of "Silent Night," moonlight bathes the Child in his crib. Subtle lighting reveals the Holy Family and the nearest, encircling angels. Candles begin to glow, lighting the faces of the host of angels ascending to the heavens. The top star catches the brilliance, and as "Joy to the World" is heralded, the landscape, the pilgrims, and their retinues are illuminated in a burst of light. One can't help but feel the presence of angels in the radiance and beauty of Loretta Howard's Angel Tree.

In 1984, Museum Director Philippe de Montebello wrote about Mrs. Howard's gift: "We are indeed grateful to her for this splendid gift, which has imparted so much beauty and joy to Museum visitors through the years. It is a tribute to its creation that the impact is never diminished as time goes by; the crèche never fails to cast a spell of enchantment over each of us."

Shortly after the acquisition, Olga Raggio, Chairman of the Department of European Sculpture and Decorative Arts at the Museum, wrote this in an article:

"By far the largest group of figures in the Howard crèche is made up of a host of delightful dimpled cherubs, delicately modeled like biscuit figurines, and some

Both angels are attributed to Angelo Viva.

96

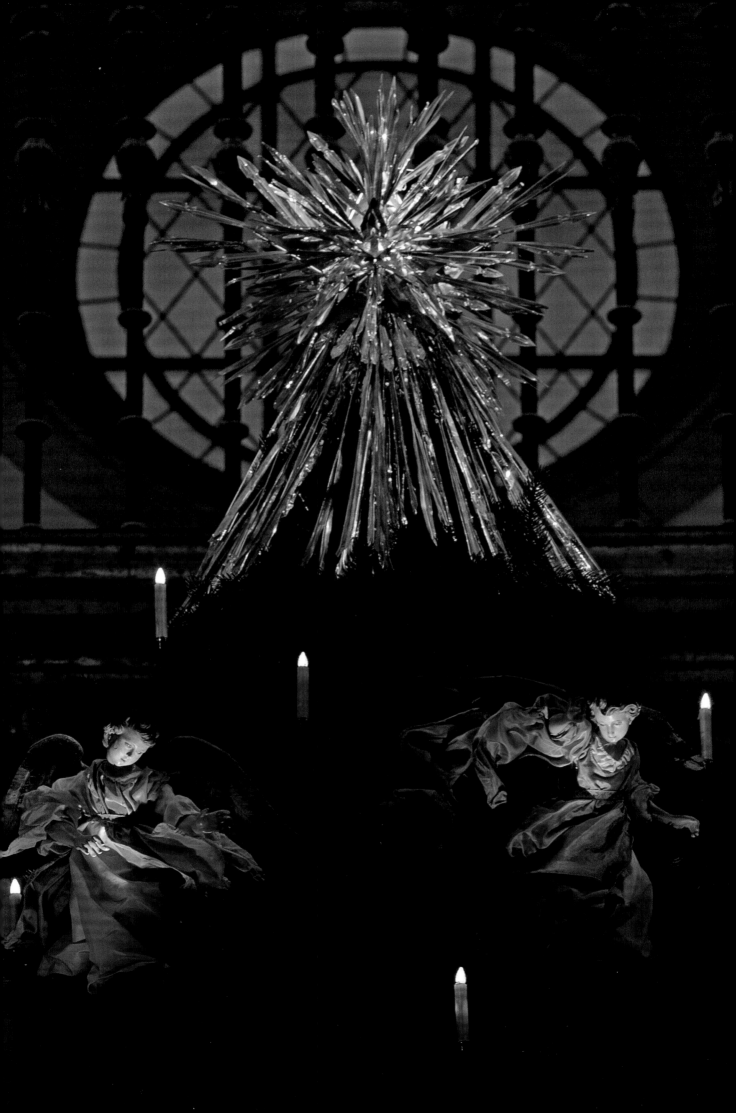

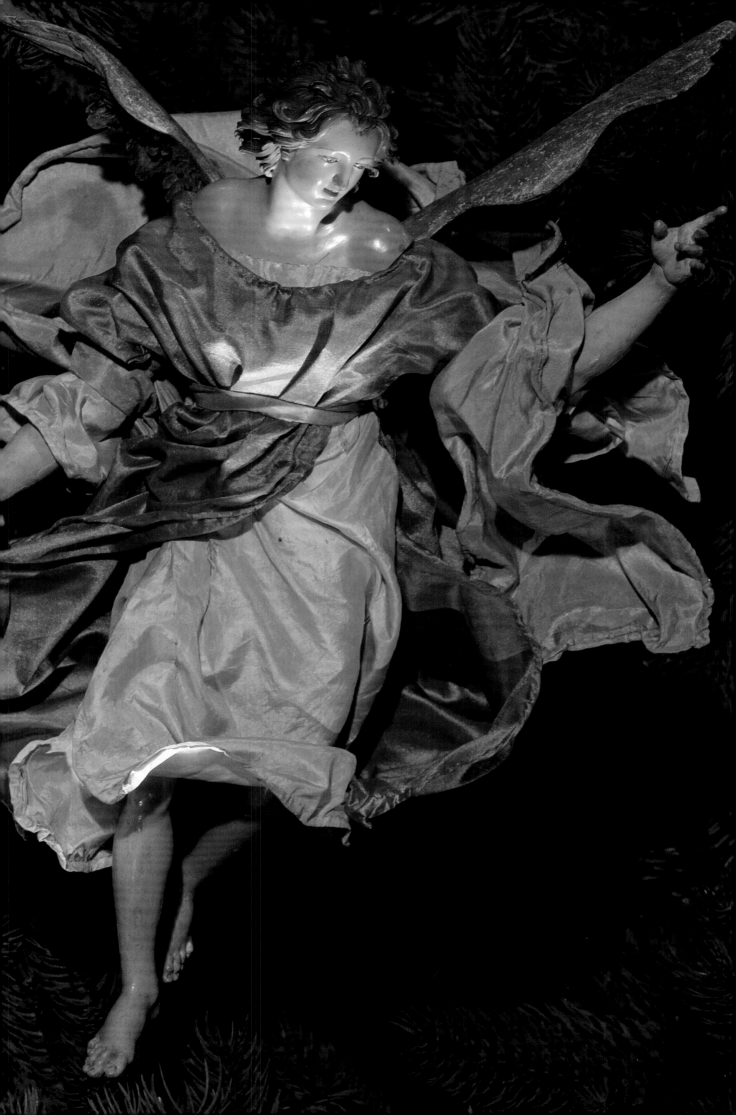

fifty large and elegant angels. These, clad in swirling pastel draperies, their hair knotted by a mystical wind, their cheeks flustered by a sweet celestial emotion, are seen swinging their finely chased silver-gilt censers or suspended in adoration. Did these heavenly creatures once belong perhaps to a famous crib set up every Christmas, until 1826, by the De Giorgio family, which had an extraordinary Glory of angels that the people flocked to admire? We will never know for sure.

"Stylistic comparisons with many signed figures in the collections of Naples, and in a documented crèche in the Bavarian National Museum in Munich, suggest that about half of the Howard angels should be credited to the best late-eighteenth-century masters: Giuseppe Sanmartino (1720–1793), well known for his monumental sculptures in marble and in stucco; his pupils Salvatore di Franco, Giuseppe Gori, and Angelo Viva, and one Lorenzo Mosca (d. 1789), who was employed at the Royal Porcelain Factory at Capodimonte and as stage director of the royal Christmas Crib.

"In the central group of The Holy Family—the *Mistero*, as Neapolitans used to call it—the noble and tender figures of Mary, Joseph, and the Babe lying in the manger are also modeled and carved with exquisite care. They are attributed to Salvatore di Franco, who is mentioned by contemporary sources as one of the best *presepio* sculptors of the time. Next are the three Magi, splendidly attired in long cloaks of silk embroidered with silver, gold, and sequins, topped with simulated ermine capes, their costume perhaps inspired by the colorful garb worn by the Knights of San Gennaro in the yearly festival in Naples. They approach the Divine Infant with expressions of tender awe and piety, marvel or mystical expectation, gesturing with their delicate, nervous hands.

"Behind the Magi came the mingled crowd of brightly dressed, exotic travelers, who symbolized the homage rendered by all nations to the Divine Child; there are Mongols and Moors mingled with Turks and Circassians, advancing on horseback or on foot, carrying their colorful trappings, banners, and lances, followed by their camels, attendants, and dogs. It is in this section of the *presepio* that the imagination of the patrons and artists, free from literal fidelity to the Scriptures, fasci-

nated by exotic costumes and types, gave itself full rein and indulged in the wildest flights, in a vein that reminds us of the *Turqueries* and the eighteenth-century opera and ballet rather than sacred drama. To these figures belong some of the most elaborate accessories: finely chased and gilded scimitars and daggers, silver baskets, and purses, all miniature masterpieces executed by Neapolitan silversmiths and other specialized craftsmen.

"A sure theatrical instinct presided over the creation of a Neapolitan Christmas crèche. The world of the exotic was counterbalanced by the more homely world of humble shepherds and simple folk, who act out their emotions and speak the language of the heart. We see some of the shepherds, clad in rough sheepskin clothes, awakened from their sleep by the Angel of the Lord, dazzled by the light that suddenly breaks through the night, or bemused by the celestial music that fills the heavens, their faces reflecting their feelings with pulsating vitality and truth. Nothing is conventional here, and the eighteenth century has hardly left us more lively and natural portraits than these. Academically trained artists, sometimes well known as porcelain-modelers—like Francesco Celebrano, to whom, among others, figures like these are often attributed—have abandoned here the formulas of 'great art' in an effort to achieve Christmas crib figures. A humorous, realistic note is struck by the sheep and goats. Skillfully modeled in terra-cotta, they are for the most part attributed to Saverio Vassallo, one of the best Neapolitan *animaliers* of the day.

"The same naturalistic vein appears in the figures of people in the inn of Bethlehem. Here are rich burghers, merchants, or valets, some of which seem to be individual portraits of exhilarating realism; peasants in gay attire of the islands of Ischia and Procida; or women coming from the countryside to peddle their produce, colorfully displayed in miniature baskets. All of them are potential actors of little genre scenes to be spontaneously set into action and made to relate to one another in chatter or in laughter, under the sharp limelight of the stage, like the characters of a miniature *commedia dell'arte*.

"The magic of the theater and the warmth of simple, sincere emotions are still today the most endearing qualities of a Neapolitan crèche."

OVERLEAF
The angel on the right is attributed to Giuseppe Sanmartino.

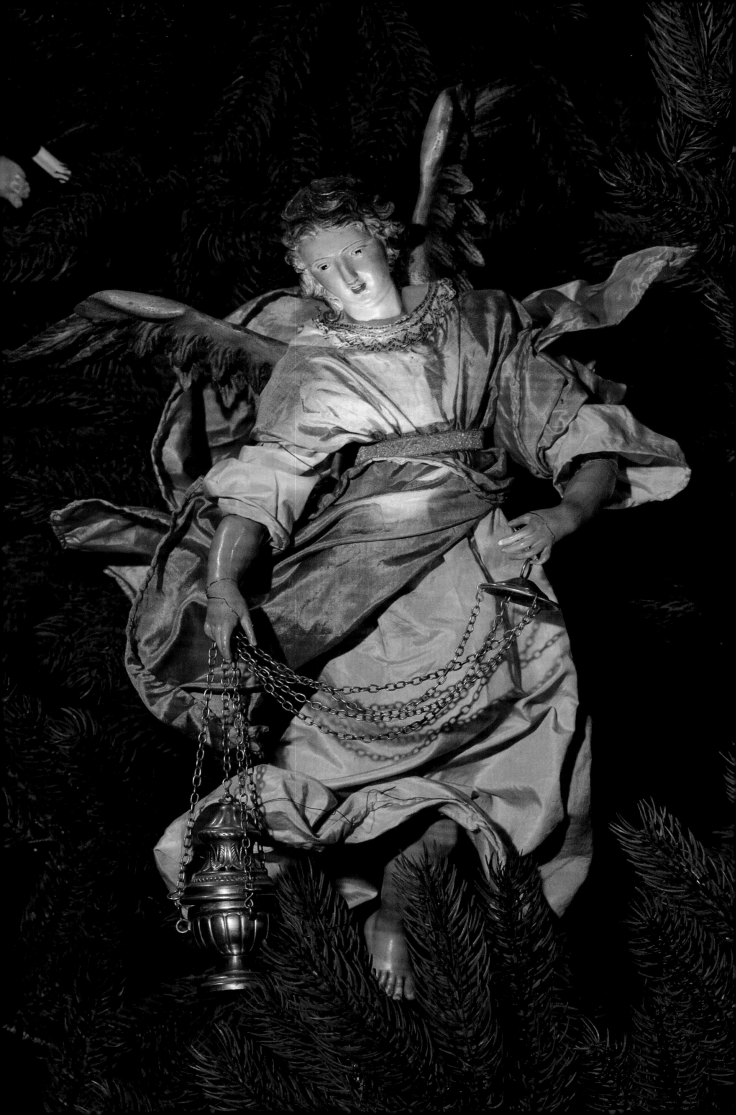

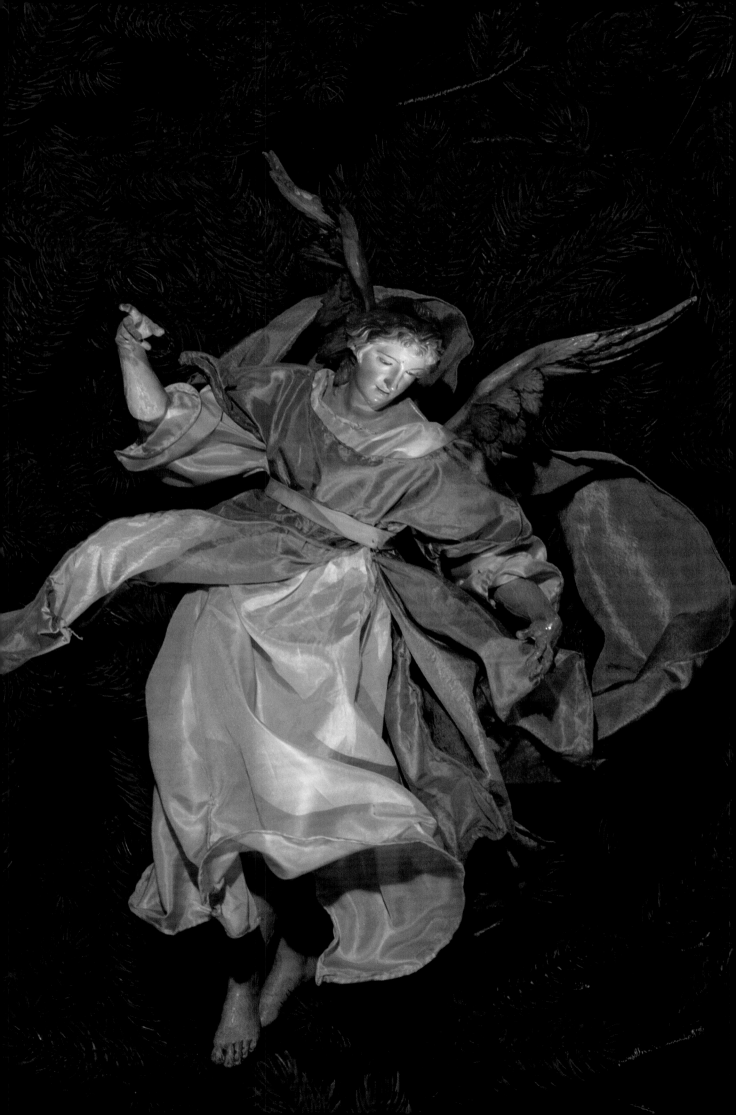

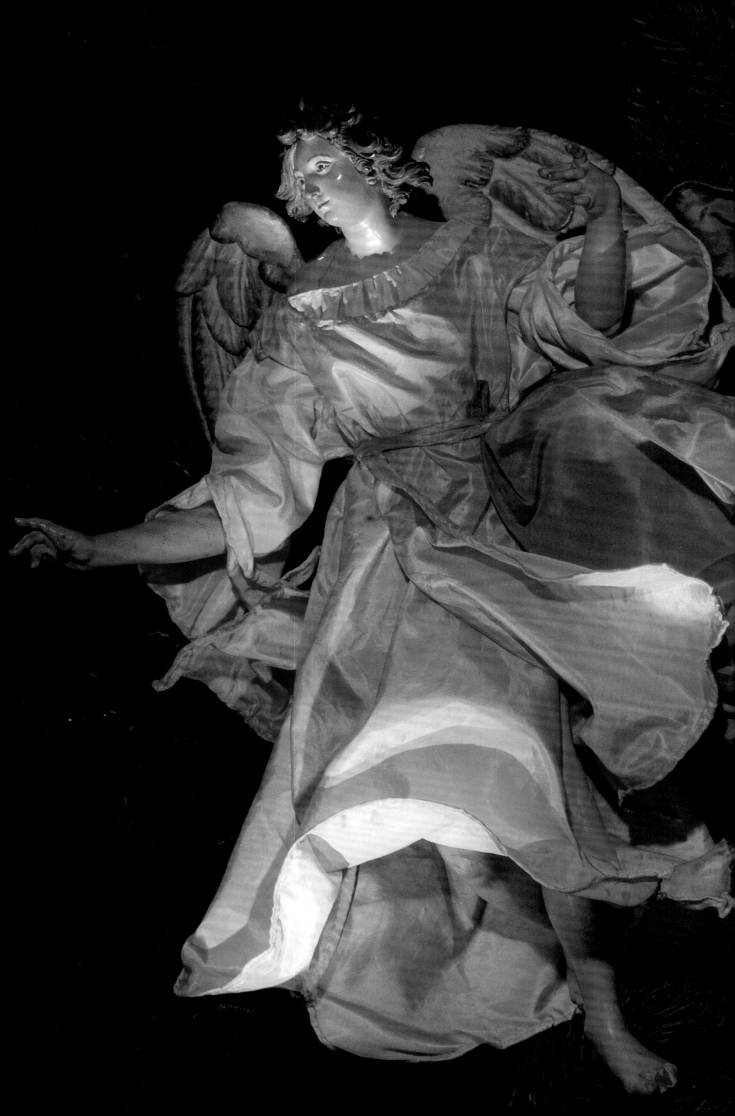

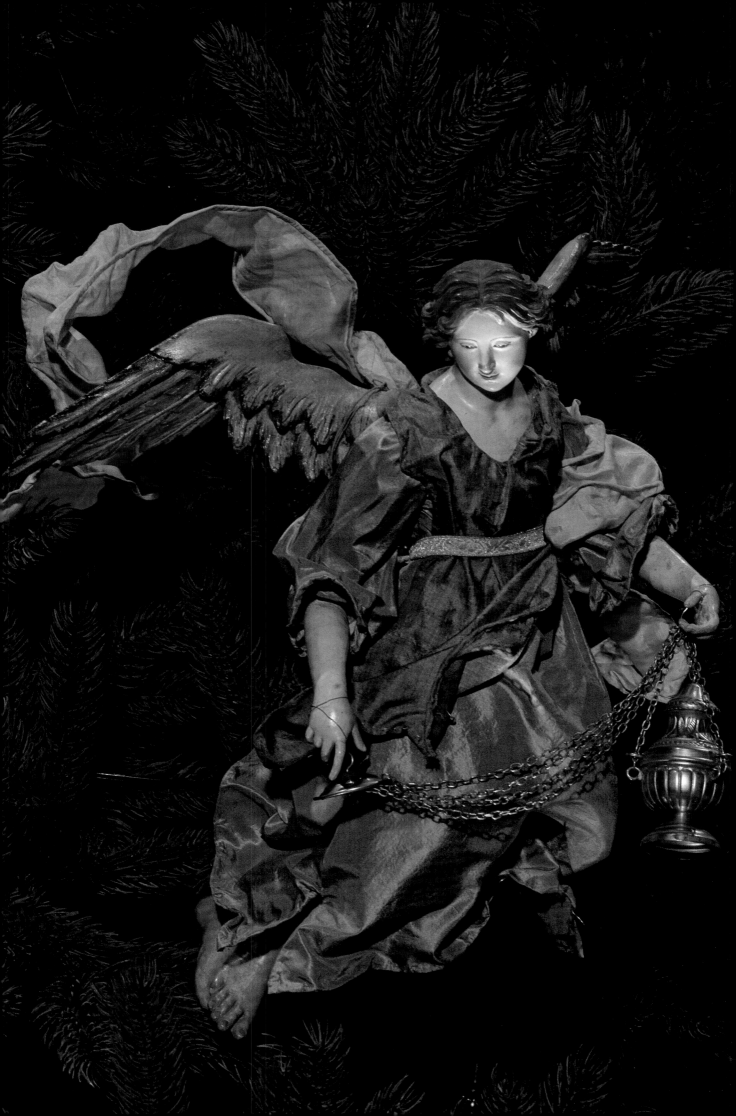

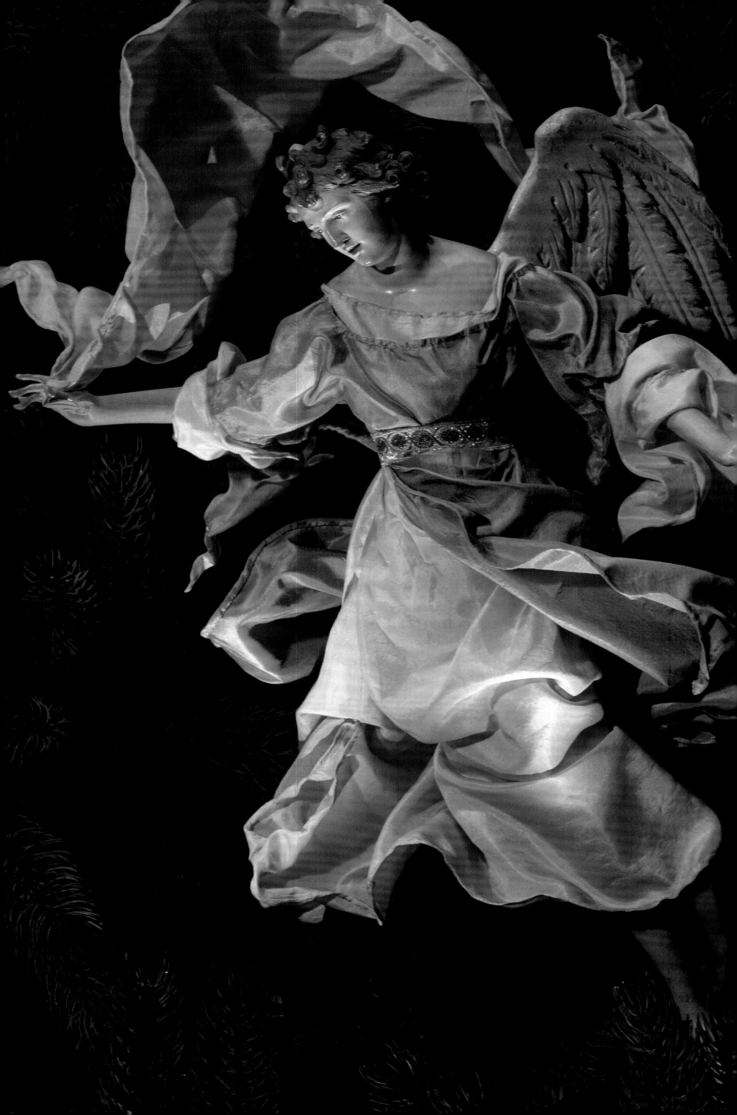

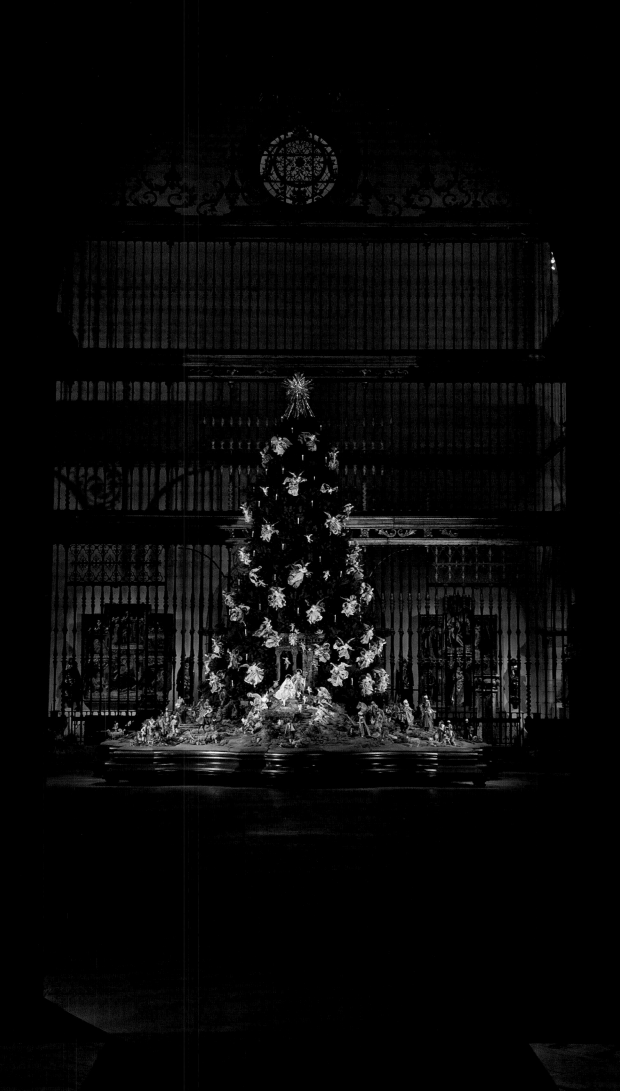

The DESIGN and INSTALLATION of the Neapolitan Crèche at the METROPOLITAN MUSEUM

THE ANGEL TREE comes to life in the Museum just in time for the Thanksgiving holiday. Work screens are put up in the Medieval Hall two weeks before, and piece by piece, like a jigsaw puzzle, the tree and landscape are assembled. At the same time, the installation team of artists unpacks the crèche storage cases, handling the eighteenth-century figures and objects with great love and care.

Work starts at the top of the tree with the star and the topmost angels. Each angel is suspended on its own metal rod, the face and colorful costumes illuminated by fiber-optic lights hidden in the tree branches. Some fifty angels are arranged as if they are in motion—flying, hovering, circling the tree—all adoring the Christ Child. They watch over the pilgrims who have come to the manger to celebrate the birth.

The landscape is treated like a stage. Each year the scene is enriched: A new thatched-roof cottage for one of the shepherds is created, or perhaps a new figure or object is added, or favorite figures are arranged in new groupings. Tiny flowers, moss, and rocks with lichen from Wyoming add something live and fresh to the sculptured terrain.

Linn Howard inherited her love of collecting religious art from her mother. The delightful deer to the right of the crib and the sleeping shepherd are Linn's

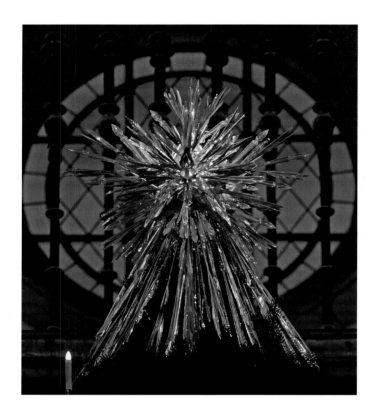

gifts to the Museum. Some seventy other pieces from her collection, on loan to the Museum, are included in the exhibition. Look for the musician playing his guitar, the vendor selling chestnuts, the lively pig, the young bull, and two flying cherubs near the waterfall. Don't miss the lobster trap, the mouse in his cage. There is a poultry vendor with a rooster and a hen. A turkey hen emerges from the stable—see the egg in her nest. Baskets of bread, sausages, onions, cheeses, and vessels of wine and water are on display at a vendor's stall, together with a large scale to weigh the merchandise. A bevy of cherubs enjoy the spectacle.

Linn and her daughter Andrea Selby continue Loretta Howard's work: installing the Angel Tree and taking great pleasure in designing something new to surprise and entertain the many-time visitor. The yearly display of the Loretta Hines Howard collection of eighteenth-century Neapolitan crèche figures at the Metropolitan Museum, with its history and current interpretation, is a joyful celebration of the spirit of Christmas.

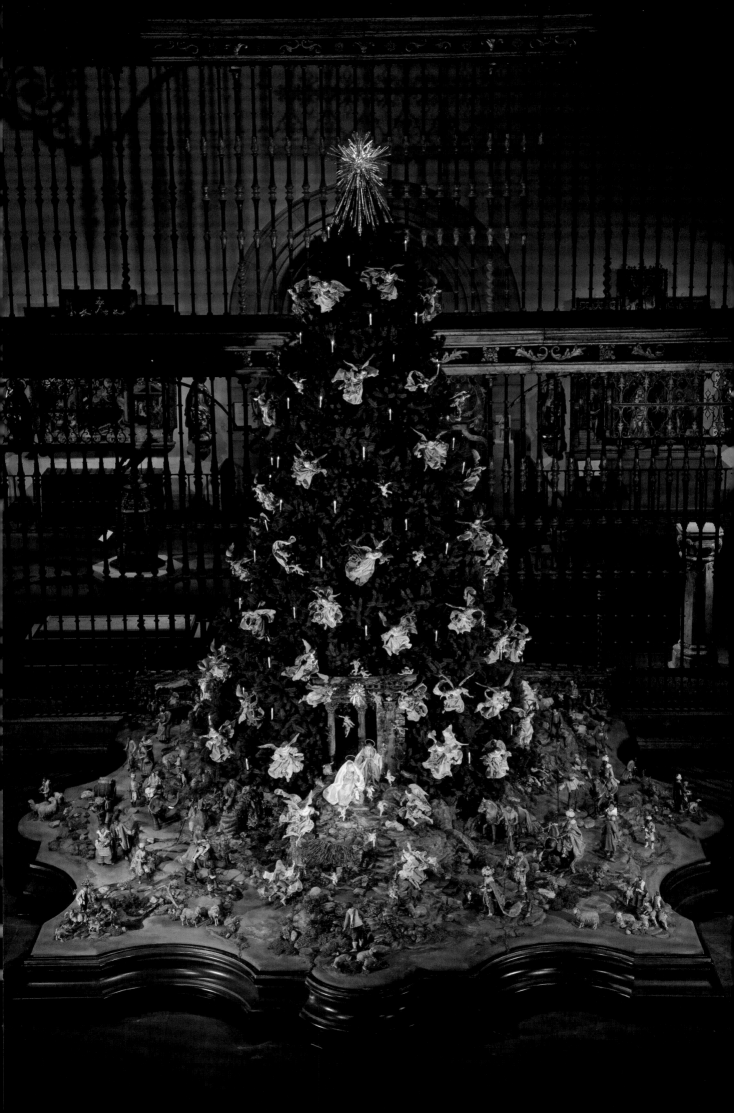

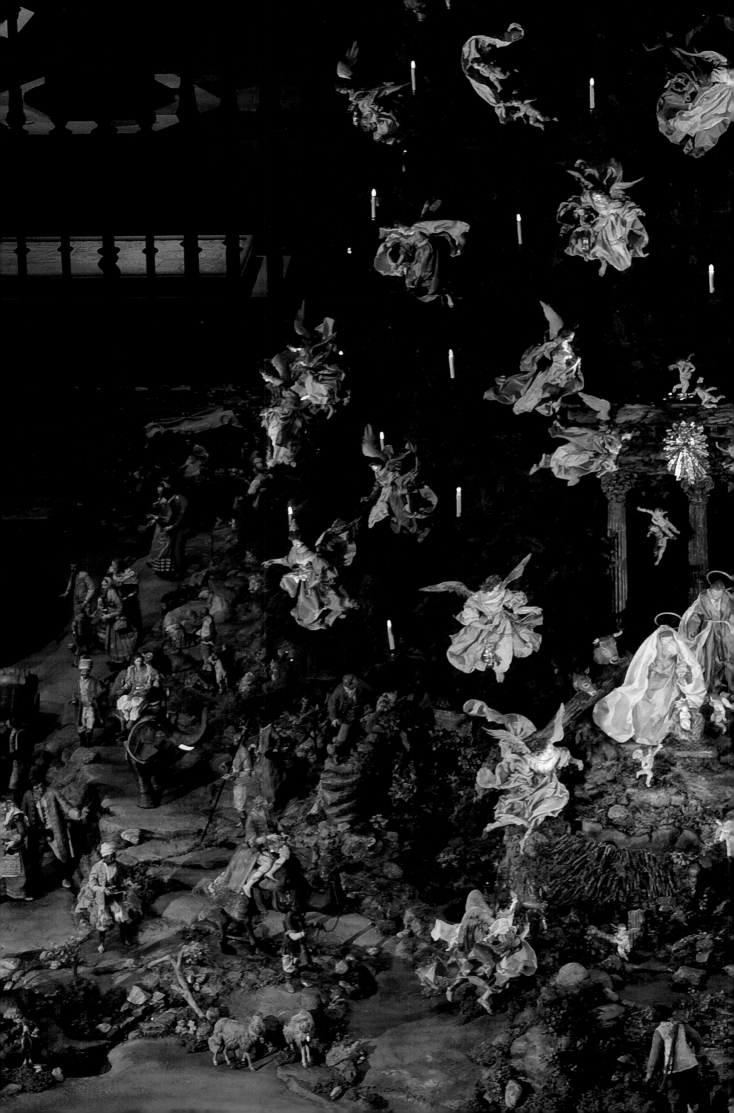

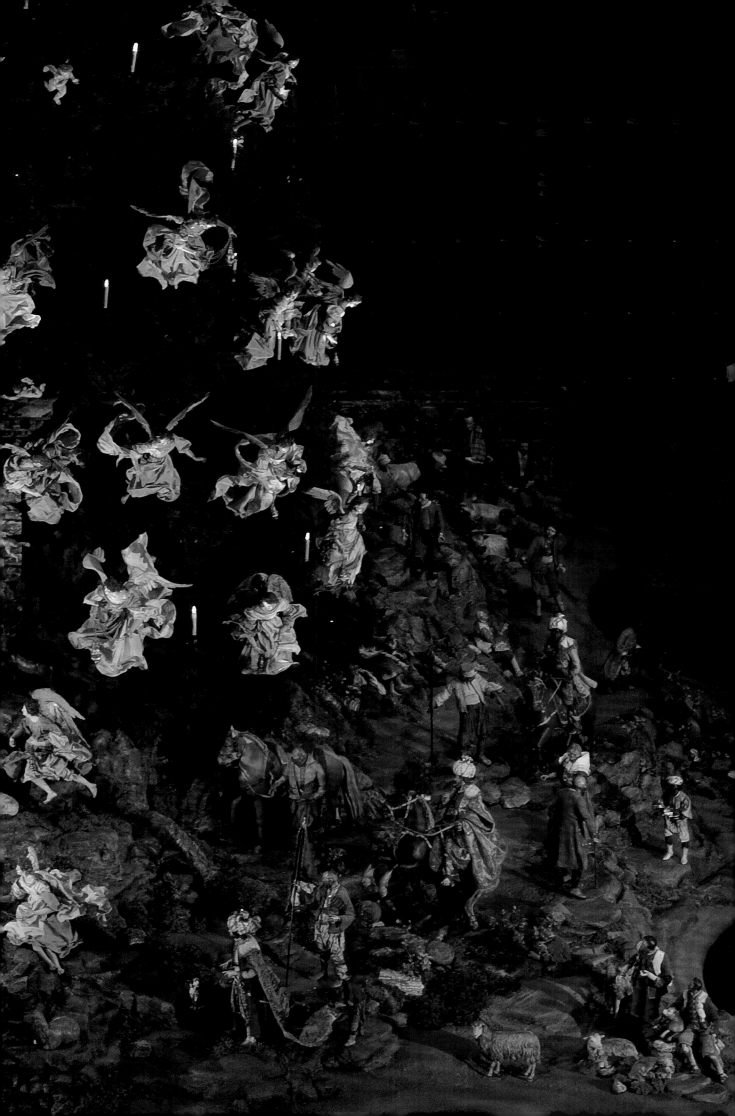

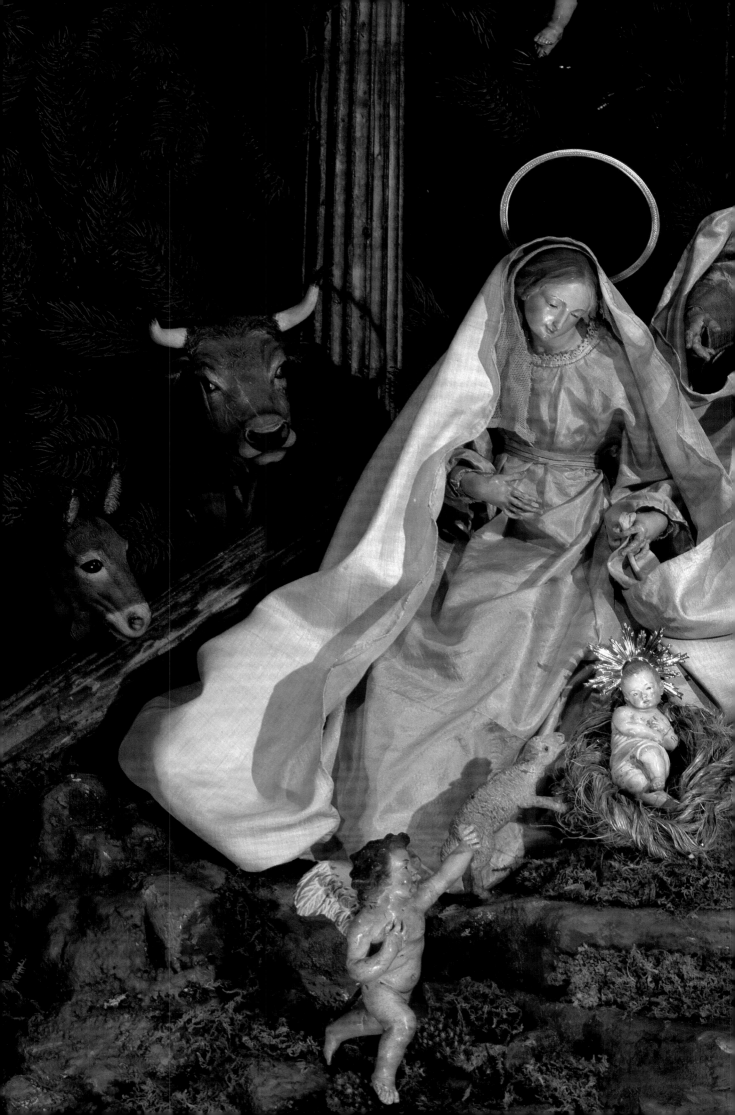

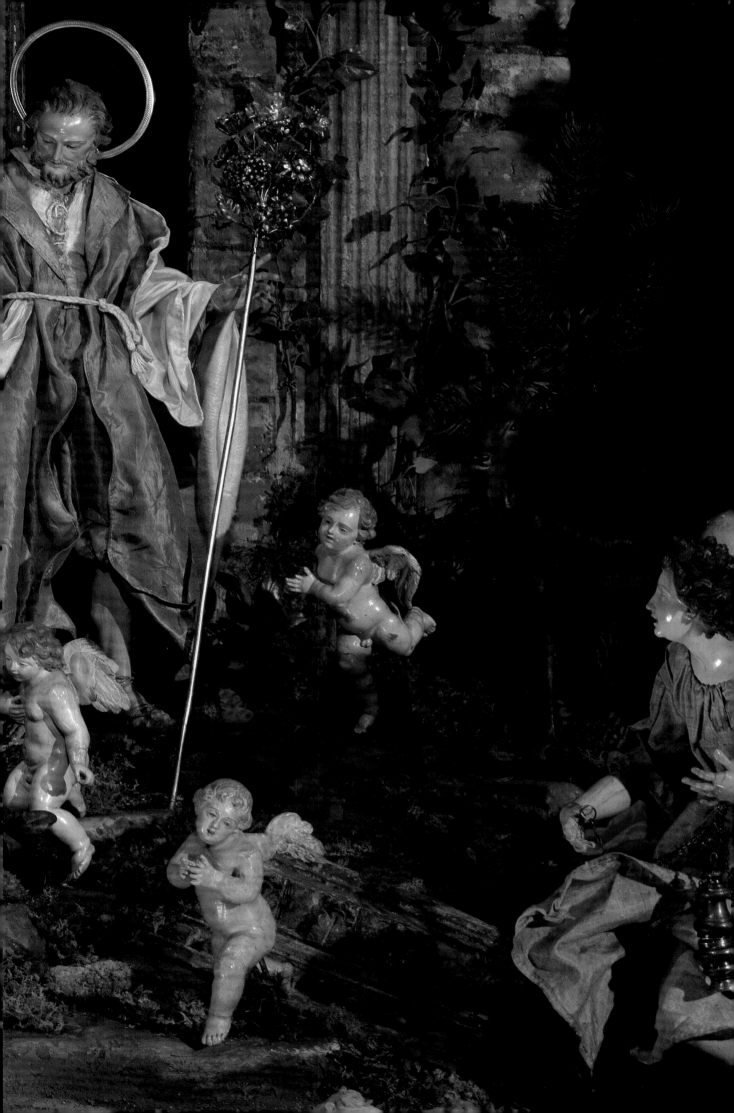

ABOUT THE ARTISTS

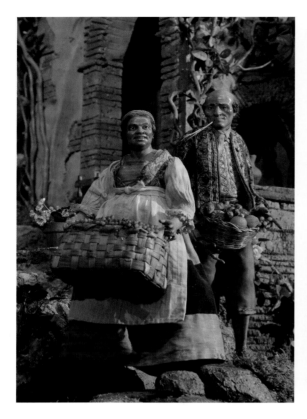

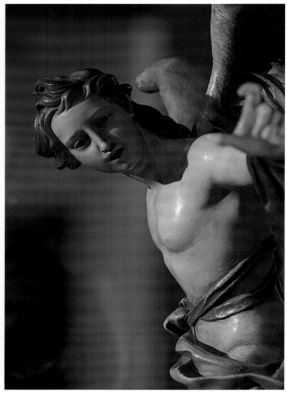

MATTEO BOTTIGLIERO (1684–1757)

As a young man, Bottigliero worked in the shop of Lorenzo Vaccaro. He and Lorenzo's son Domenico are considered the leading sculptors in Naples during the first half of the eighteenth century. Bottigliero's work can be seen in churches and monasteries, including the Monastero di S. Gregorio Armeno, the Chiesa del Gesù Nuovo, and the Chiesa del Carmine. The silver statue of S. Andrew the Apostle in the Amalfi Cathedral was made to his design. Figures in some of the most renowned *presepi* in Naples and the peasant woman with a basket of grapes in the Howard crèche are attributed to him.

FRANCESCO CELEBRANO (1729–1814)

Celebrano was a painter and sculptor with many commissions and appointments from Ferdinado IV, among them Painter to the Royal Chamber and Tutor of the Duke of Calabria. It was recorded in 1772 that he was an expert modeler at the Portici porcelain factory. He is most known for the high-relief marble of the *Deposition* (1776) and the Sepulcher of Cecco di Sangro in the Sansevero Chapel in Naples. In 1800, he assembled and installed a large crib in Palermo, where the Bourbon court spent the Christmas season. A completely sculpted terra-cotta angel in the Howard crèche is attributed to him.

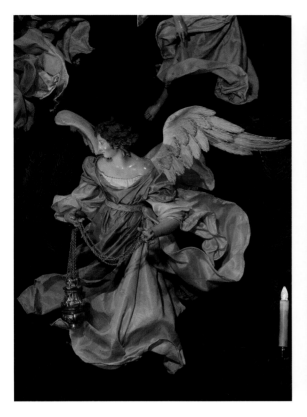

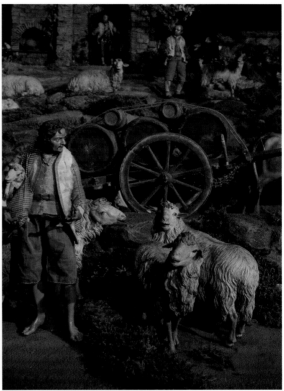

SALVATORE DI FRANCO
(late 18th and 19th centuries)

Di Franco is considered one of Giuseppe Sanmartino's most imaginative pupils. His sculpture may be seen in a number of churches in Naples: The Sepulcher of Giovanni Assenzio de Goyzueta in the Chiesa della Nunziatella and the figure of S. Benedetto in the Chiesa dell'Eremo dei Camaldoli are two of his most monumental works. He is known for the realism of his faces and figures. Seven of the figures in the Howard crèche are attributed to him: the Virgin, Saint Joseph, and five angels.

FRANCESCO GALLO
(late 18th and 19th centuries)

Old inventories of *presepi* list Francesco Gallo as a maker of animals, and it is known that he was a modeler at the Royal Porcelain Factory in Palermo in 1788. Records show that he used animals in the Royal Zoo in Naples as inspiration, including the elephant that arrived with the Turkish Embassy. In 1804, he modeled two dogs for the Heir Apparent. The Howard collection contains two sheep and a finely sculpted young bull attributed to the artist.

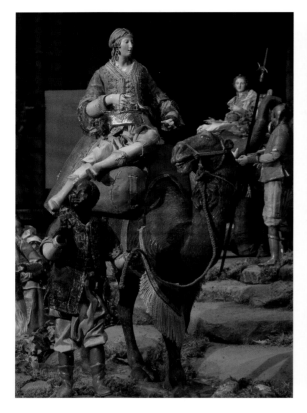 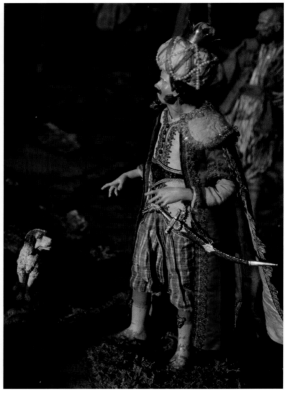

GIUSEPPE GORI (late 18th and 19th centuries)

Gori was a pupil of Giuseppe Sanmartino and was said to be one of his best disciples and very near in style to his master. Gori's work bridged the Baroque and Neoclassical periods. A variety of crèche figures range from sublime angels to country folk and exotic travelers. He often portrayed his patrons and their animals. In the Howard crèche there are five angels, one man, one king's Oriental attendant, and a bejeweled lady on a camel attributed to Gori.

NICOLA INGALDI (late 18th and 19th centuries)

Ingaldi was a man of various skills. In 1862, his statue of the Blessed Virgin was inaugurated in the old Chiesa del Gesù in the presence of royalty. Along with several members of his family, he was a modeler of numerous *presepio* figures. His shepherds and animals appear in the inventories of Francesco I and Ferdinando II, and state archives show that he applied for a position in the Royal Porcelain Factory. His work was strongly influenced by that of Giuseppe Sanmartino and Giuseppe Gori. A king and an angel in the Howard crèche are attributed to Ingaldi.

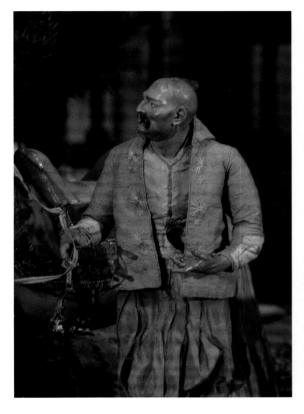

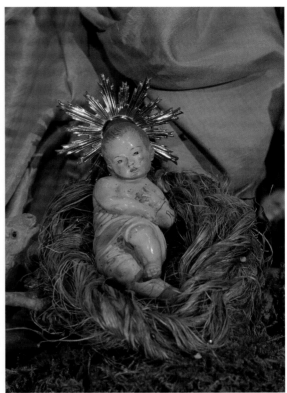

LORENZO MOSCA (d. 1789)

Described as a dilettante who became a sculptor, Lorenzo Mosca "directed" cribs for many years, including one for the De Giorgio family. It has been suggested that a number of the figures in the Howard crèche may have come from the De Giorgio collection. To meet the great demand for his work, he used plaster casts, taking care to see that each piece was well finished and painted. He liked to dress families of figures in the costumes of nearby regions: Abruzzo, Calabria, Procida, and Torre del Greco. The Howard crèche contains three angels, a shepherd, a man, a woman, and a king's Oriental attendant attributed to Mosca.

GIUSEPPE SANMARTINO (1720–1793)

Prolific and talented, Giuseppe Sanmartino (also known as Sammartino) is considered the leading Neapolitan sculptor of the eighteenth century. His work can be seen in many churches in Naples and the surrounding region. The veiled Christ in the Sansevero Chapel in the Church of S. Ferdinando is considered his masterpiece. His interest in crib figures brought *presepio* art to a new height. His modeling was particularly expressive and inspired a number of his pupils to copy his sense of realism. The following figures in the Howard crèche are attributed to Giuseppe Sanmartino: the Infant Jesus, five angels, a pair of cherubs, and one king's Oriental attendant.

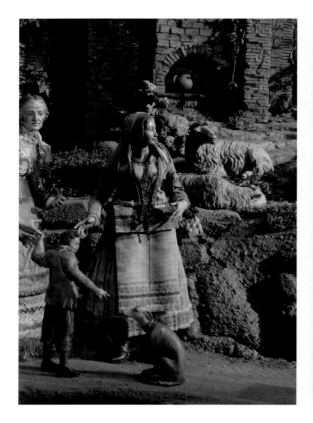

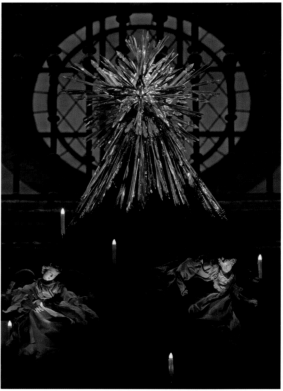

NICOLA AND SAVERIO VASSALLO
(18th and 19th centuries)

The Vassallo brothers, sons of the sculptor Onofrio Vassallo and pupils of Francesco di Nardo, were famous for their *presepio* figures of animals. They worked in terra-cotta and wood, and often combined these and other materials. For example, in the Howard crèche the five sheep attributed to the Vassallos are a mixture: a terra-cotta body with lead legs and ears; or, if the sheep is reclining, the ears may be carved of wood. It is known that the Vassallos liked to work from life, and that in one instance they used the dogs from the pack of Ferdinando IV as models for figures commissioned for the elaborate Ruggiero crib.

ANGELO VIVA (1748–1837)

Like his teacher Giuseppe Sanmartino, Viva was a prolific sculptor in marble and terra-cotta. His figures can be seen in the churches of S. Paolo Maggiore, the Nunziatella, and the Museo Nazionale de S. Martino. It is evident that his later work was influenced by the Neoclassical movement. Two angels in the Howard crèche are attributed to him.

OPPOSITE AND OVERLEAF
These angels are attributed to Giuseppe Sanmartino.

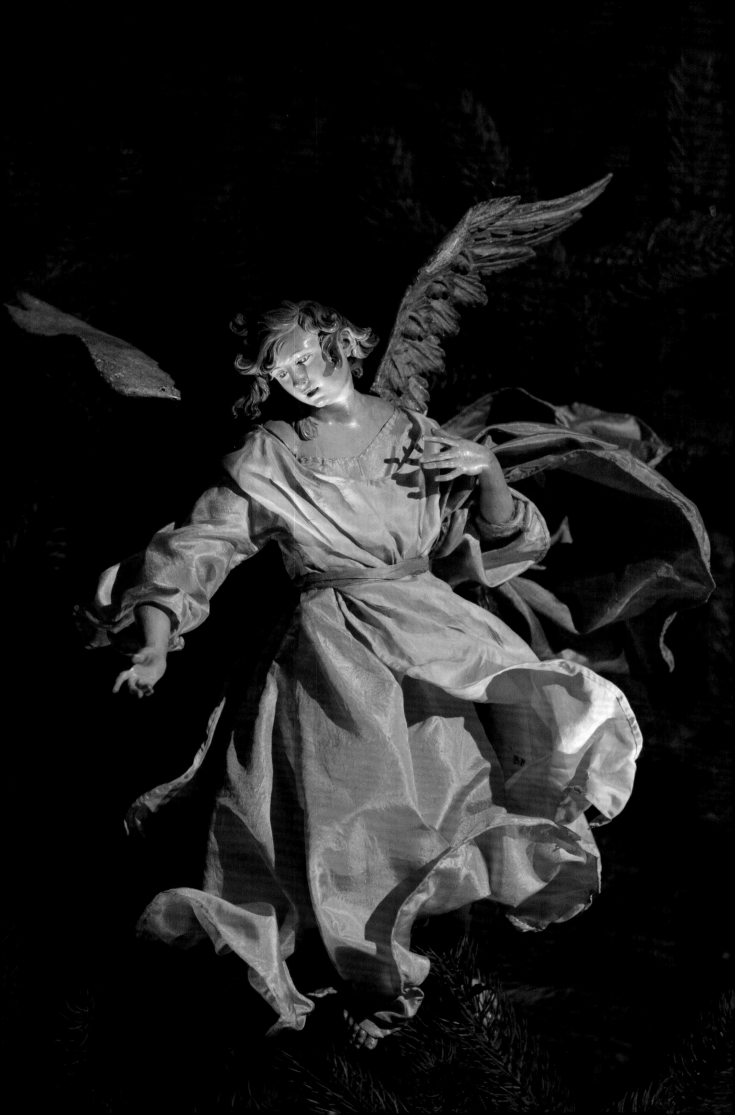

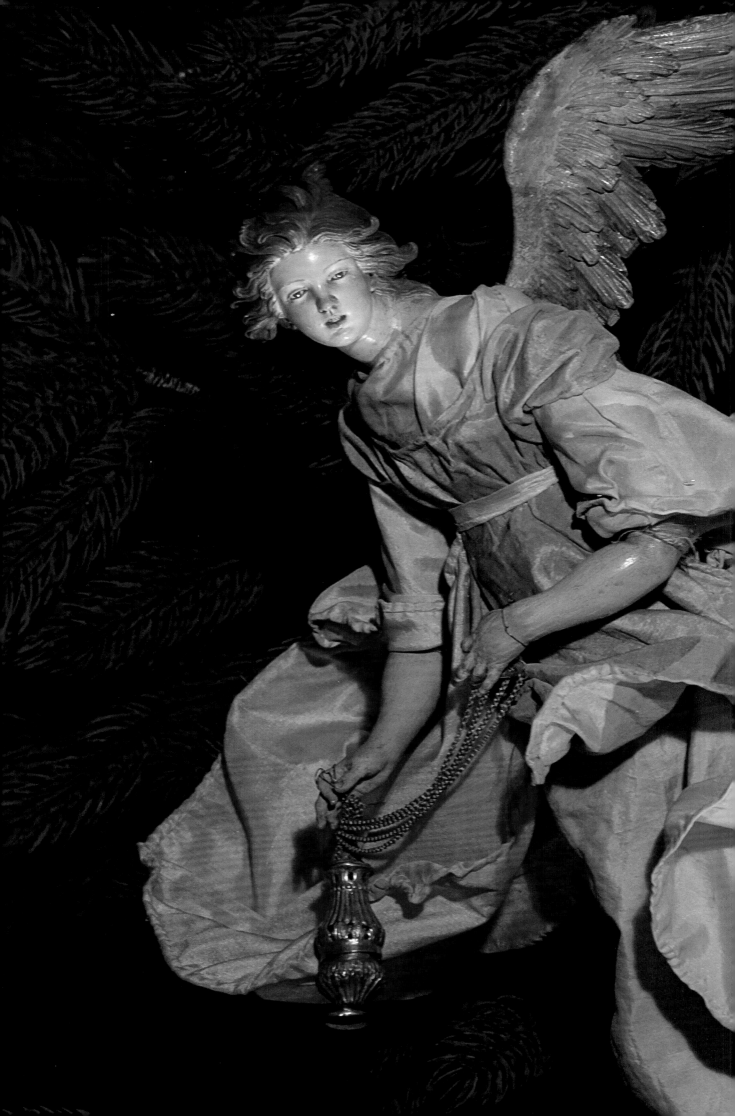

BIBLIOGRAPHY

Berliner, Rudolf. "The Origins of the Crèche." *Gazette des beaux-arts*, October-November-December 1946.

————. *Die Weihnachtskrippe*. Munich, 1955.

Bolz, Diane M. "Art Imitates Life in the Small World of Baroque Crèches." *Smithsonian*, December 1991.

Borelli, Gennaro. *Il presepio napoletano*. Rome, 1970.

————. "Sanmartino, scultore per il presepe napoletano." Naples, 1966.

Castaldo, Giuseppe. "Christmas in Naples." *Italy Italy*, November 15–December 15, 1989.

Catello, Marisa Piccolli, ed. *Art of the Presepio: The Neapolitan Crib of the Banco di Napoli Collection*. Essays by Raffaelo Causa and Nicola Spinosa. Naples, 1987.

Causa, Raffaello. "Cinque secoli di presepe." *Civiltà della campania*. December 1974.

————. "Miracle Play." *FMR*, December 1984.

————. "Napoli di Galilea." *FMR*, December 1982.

————. "Il presepe cortese." *Civiltà del '700 a Napoli, 1734–1799*. Naples, n.d.

————. *Il presepe napolitano di Casa Leonetti*. Italy, n.d.

De Robeck, Nesta. *The Christmas Crib*. Milwaukee: The Bruce Publishing Company, 1956.

————. *The Christmas Presepio in Italy*. Florence, 1934.

De Vita, Oretta Zanni. "Gold, Frankincense, Myrrh and Maccaroni." *Italy Italy*, November 15–December 15, 1989.

Fidelfo, Margherita. "A Naples Crèche Goes to Pittsburgh." *Italy Italy*, November 15–December 15, 1989.

Fittipaldi, Teodoro. *Scultura napoletano del settecento*. Naples, 1980.

Fuhrimann, Klara von. "Neapolitanische Weihnachtskrippen." *Kulturelle Monatsschrift*. Christmas 1965.

Howard, Linn, and Mary Jane Pool. *The Angel Tree*. New York: Alfred A. Knopf, 1984.

————. *The Angel Tree: A Christmas Celebration*. New York: Harry N. Abrams, 1994.

————. *The Christmas Story*. New York: Harry N. Abrams, 2001.

Howard, Loretta Hines. *The Nativity: The Christmas Crèche at The Metropolitan Museum of Art*. New York: Doubleday and Company, 1969.

Mancini, Franco. *Il presepe napoletano nella collezione Eugene Catello*. Naples, 1965.

————. *Il presepe napoletano: Scritte e testimonianze dal secolo XVIII al 1955*. Naples, 1983.

Miles, Joan. "A World Made in Miniature." *Italy Italy*, December 1990.

Molajoli, B. *La scultura nel presepio napoletano del settecento*. Naples, 1950.

Perrone, Antonio. "Historic Notes on the Nativity Scene." Naples, 1896.

Presepio a San Martino. Exhibition catalogue. Naples, 1964.

Prisco, Michele. "Il presepe in provincia." *Civiltà della campania*. December 1974.

Raggio, Olga. "A Neapolitan Christmas Crib from the Loretta Hines Howard Collection." *The Metropolitan Museum of Art Bulletin*, December 1965. Updated and published separately, New York: The Metropolitan Museum of Art, 1976.

Rea, Domenico. "L'universo mangereccio del presepe." *Civiltà della campania*. December, 1974.

Spaeth, Eloise. *Two Eighteenth-Century Neapolitan Crèches*. New York, 1961.

Spinosa, Nicola. *Figure presepiali napoletane dal sec. XVI al sec. XVIII*. Azienda Autonoma di Cura Soggiorno e Turismo. October 1970/January, 1971.

Stefanile, Mario. "I presepi d'un volta." *Civiltà della campania*. December 1974.

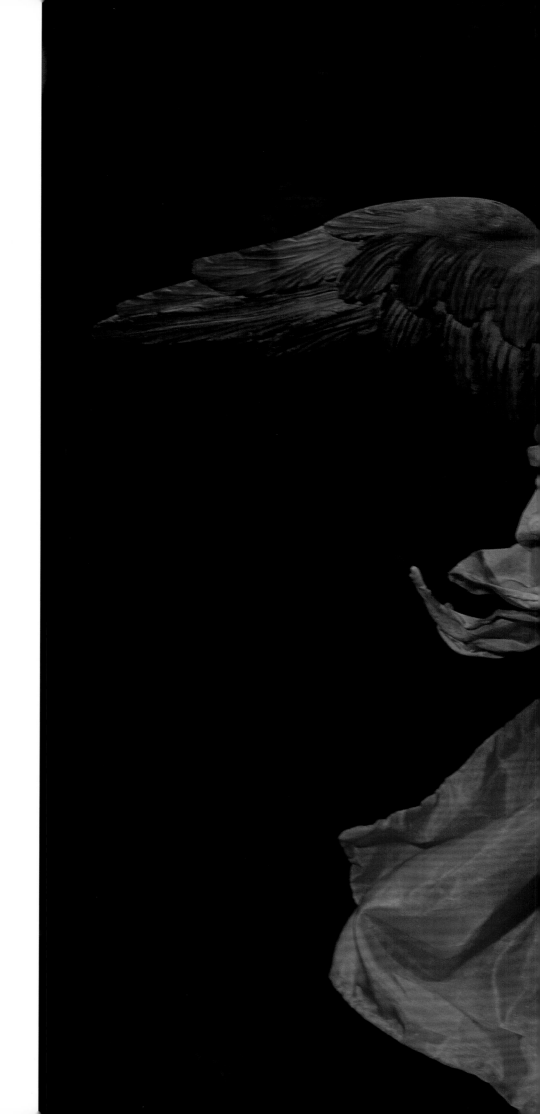

This angel is attributed
to Salvatore di Franco.

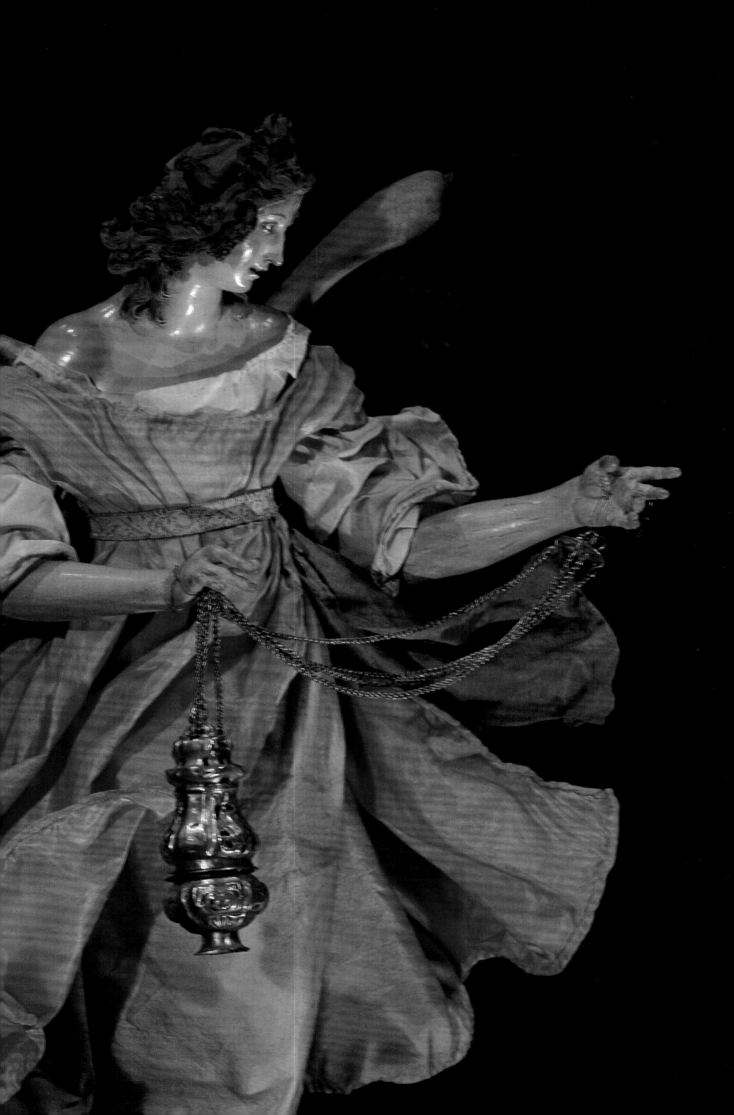

ACKNOWLEDGMENTS

A NEW ANGEL TREE, with a redesigned installation of the Loretta Hines Howard Neapolitan Crèche Collection, appeared for the first time in the Metropolitan Museum's Medieval Hall in 2008. Abrams editor Margaret L. Kaplan suggested we do a new book to herald the event. Like so many good things, it has taken time to bring the book to life. Many have helped us, and we want to thank each of them.

We have had wonderful support from the Museum. Thomas P. Campbell, its director, has written a most gracious foreword to the book. Emily Rafferty, its president, encouraged us from the very beginning and paved the way. Our text has been enriched tremendously with the colorful and scholarly descriptions of the crèche figures by late curator Olga Raggio. We turned to Johanna Hecht often for information and curatorial opinion. We are also most grateful to members of the European Sculpture and Decorative Arts department: Ian Wardropper and Wolfram Koeppe. We particularly want to thank Marilyn Jensen, the Museum's book buyer, who supported the project, as did Publishing Manager Robie Rogge and Senior Associate Counsel Cristina del Valle.

Photo sessions took place after Museum hours on two cold December nights. Elliott Erwitt's extraordinary eye produced the most beautiful photographs. This is indeed his book, and joins a long list of volumes in which he has documented the world so dramatically. Zak Powers was Elliott's technician on the shoot and continued to help us as we went along.

At Abrams, Margaret Kaplan's early enthusiasm and constant encouragement have carried us on her wings. Darilyn Carnes's brilliant design tells the story just as we wanted it told. And we are very grateful to Anet Sirna-Bruder and her production staff for a most handsomely produced book. This is our fourth volume featuring the Angel Tree and the third that Abrams has published.

The new tree that led us to do this book was created by Holiday Image Inc. to the Museum's specifications. Polly Wood-Holland of Hudson Scenic Studio is responsible for the new landscape. The fiber-optic lighting was designed by Luxam. All of this was overseen by the Museum's staff for Special Exhibitions, Gallery Installations, and Design: Linda Sylling, Patricia Gilkison, Clint Coller, Rich Lichte, and Michael Lapthorn. Ricardo Serrano and Greg Piscitelle were the electricians on the job. This very able staff sees that the installations of the Angel Tree go smoothly.

The exhibition photographed for the present volume was created by the following talented artists: Andrea Selby, Arthur Bruder, Gemma Rossi, Lynne Block, Patricia Hogan, and Melissa Metrick. It is this installation team that arranges the crèche figures and objects, designing new scenes and groupings to intrigue viewers. Through the years, Loretta Howard's granddaughters, Andrea Selby and Stephanie De Pierro, have been part of the team, along with Susan Roschen and other gifted friends. This book is a tribute to the work of many hands and much good will.

L.H., M.J.P.

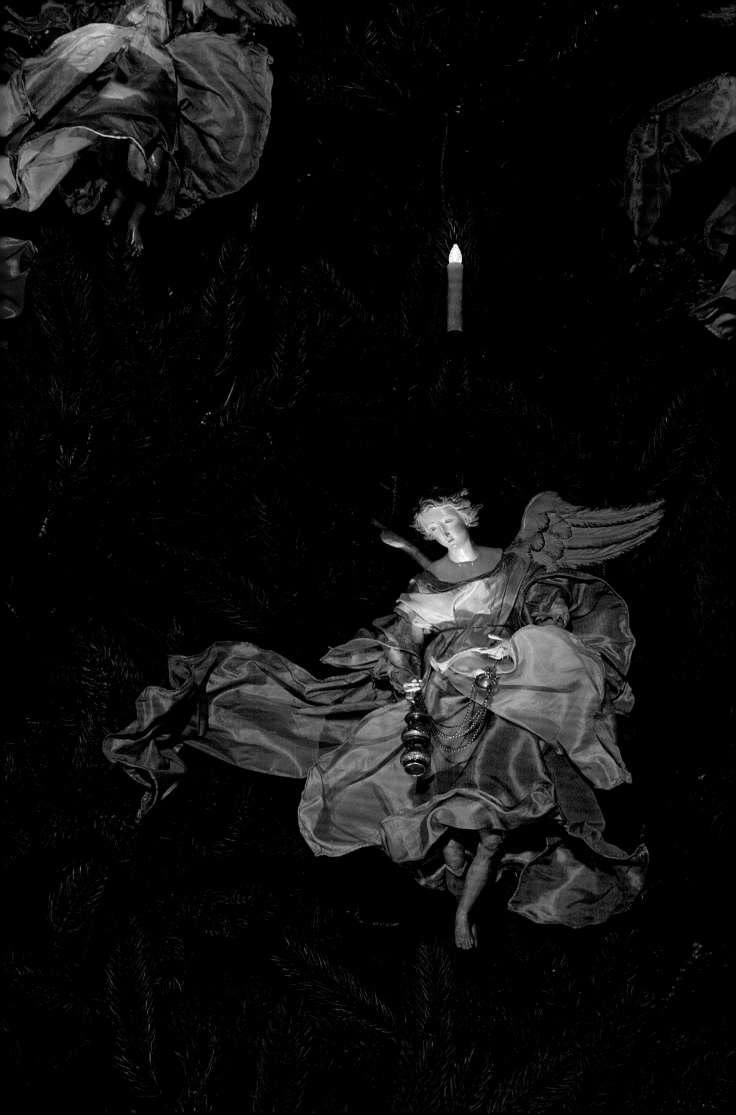

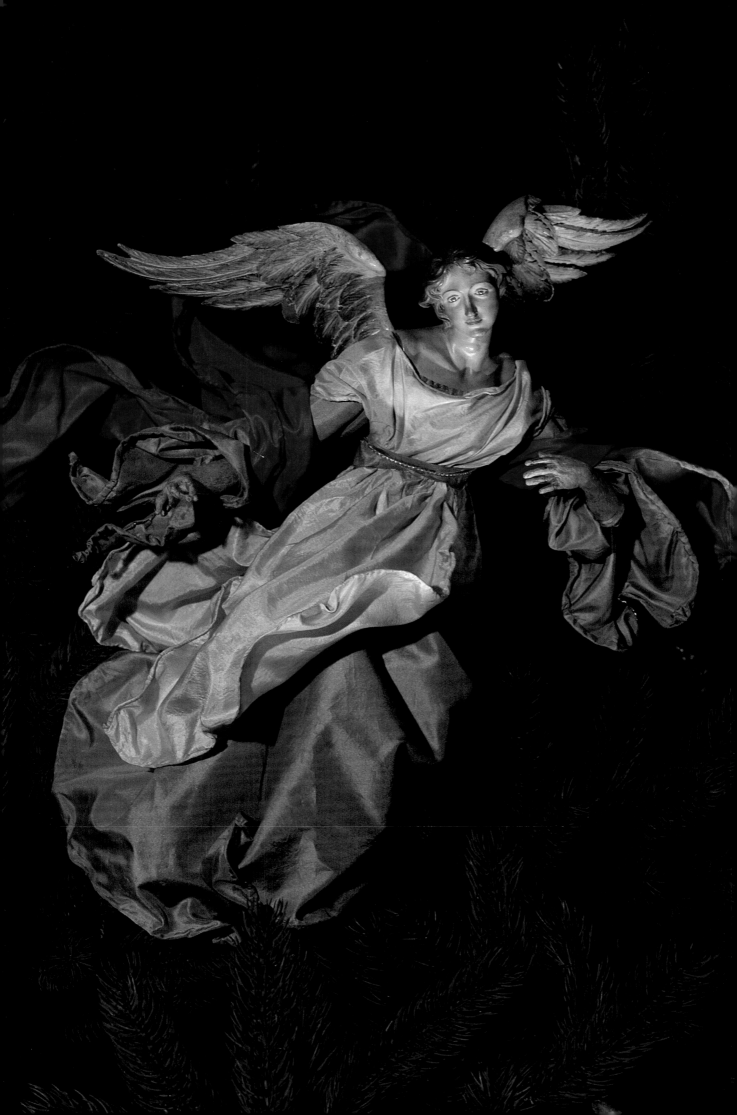

ABOUT THE AUTHORS

LINN HOWARD assisted her mother, Loretta Howard, with the installation of the tree and crèche at The Metropolitan Museum of Art. Now she and her daughter, Andrea Selby, continue Mrs. Howard's work. Linn traveled with her mother in Europe on collecting trips and has her own collection of crèches. Each year she lends some seventy figures and objects to the Museum for the Angel Tree exhibition, and she lectures on the crèche across the country. She studied art and dancing and was a member of the Alwin Nikolais Dance Company. Her decoupage is prized by collectors. When first married, she lived in Nepal; now she summers on her ranch in Wyoming. The remainder of the year she lives in New York City, where she brought up her three children.

MARY JANE POOL has a special interest in eighteenth-century decorative arts and collects painted Venetian furniture of that period. She has served on the board of the Isabel O'Neil Foundation for the Art of the Painted Finish and is a governor of the Decorative Arts Trust. For a number of years she was an editor of *Vogue* magazine, and from 1970 to 1981 she was the editor in chief of *House & Garden*. Her other books include *The Gardens of Venice*; *The Gardens of Florence*; and *Gardens in the City: New York in Bloom*.

ELLIOTT ERWITT has been a professional photographer since he was a teenager living in Hollywood. From 1948 on, his work has appeared, both as illustrations and in advertisements, in virtually every European, Asian, and American popular magazine. He has made numerous documentary films for television. His photographs have been exhibited and are part of collections in major galleries and museums around the world. His books include *Photographs and Anti-Photographs*; *Son of Bitch*; *Observations on American Architecture*; *Recent Developments*; *Personal Exposures*; *On the Beach*; *Elliott Erwitt: To the Dogs*; *Museum Watching*; *SNAPS*; *Between the Sexes*; *Personal Best*; *UNSEEN*; *Elliott Erwitt's Dogs*; *Elliott Erwitt's Rome*; *Elliott Erwitt's New York*; and *Elliott Erwitt's Paris*. He has been a member of Magnum Photos, the international photographers' cooperative, since 1953.

OPPOSITE
This angel is attributed to
Giuseppe Sanmartino.

Project Manager and Editor: Margaret L. Kaplan
Designer: Darilyn Lowe Carnes
Production Manager: Anet Sirna-Bruder

Library of Congress Cataloging-in-Publication Data

The Metropolitan Museum of Art (New York, N.Y.)
 The angel tree : celebrating Christmas at The Metropolitan Museum
of Art : the Loretta Hines Howard collection of eighteenth-century
Neapolitan crèche figures / Linn Howard and Mary Jane Pool;
photographs by Elliott Erwitt.
 p. cm.
 Includes bibliographical references.
 ISBN 978-0-8109-9692-2
1. Crèches (Nativity scenes)—Italy—Naples—History—18th
century. 2. Decorative arts—Italy—Naples—History—18th century.
3. Howard, Loretta Hines—Art collections. 4. Crèches (Nativity
scenes)—Private collections—New York (State)—New York.
5. The Metropolitan Museum of Art (New York, N.Y.) I. Howard, Linn.
II. Pool, Mary Jane. III. Erwitt, Elliott. IV. Title. V. Title:
Celebrating Christmas at The Metropolitan Museum of Art.
VI. Title: Loretta Hines Howard collection of eighteenth-century
Neapolitan crèche figures.
 N8065.M48 2011
704.9'4856094573—dc22
 2010045057
 ISBN 978-0-8109-9692-2

Printed and bound in China
10 9 8 7 6 5 4 3 2 1

ABRAMS
THE ART OF BOOKS SINCE 1949
115 West 18th Street
New York, NY 10011
www.abramsbooks.com

pages 4–5 and 7: These angels are attributed to Salvatore di Franco.

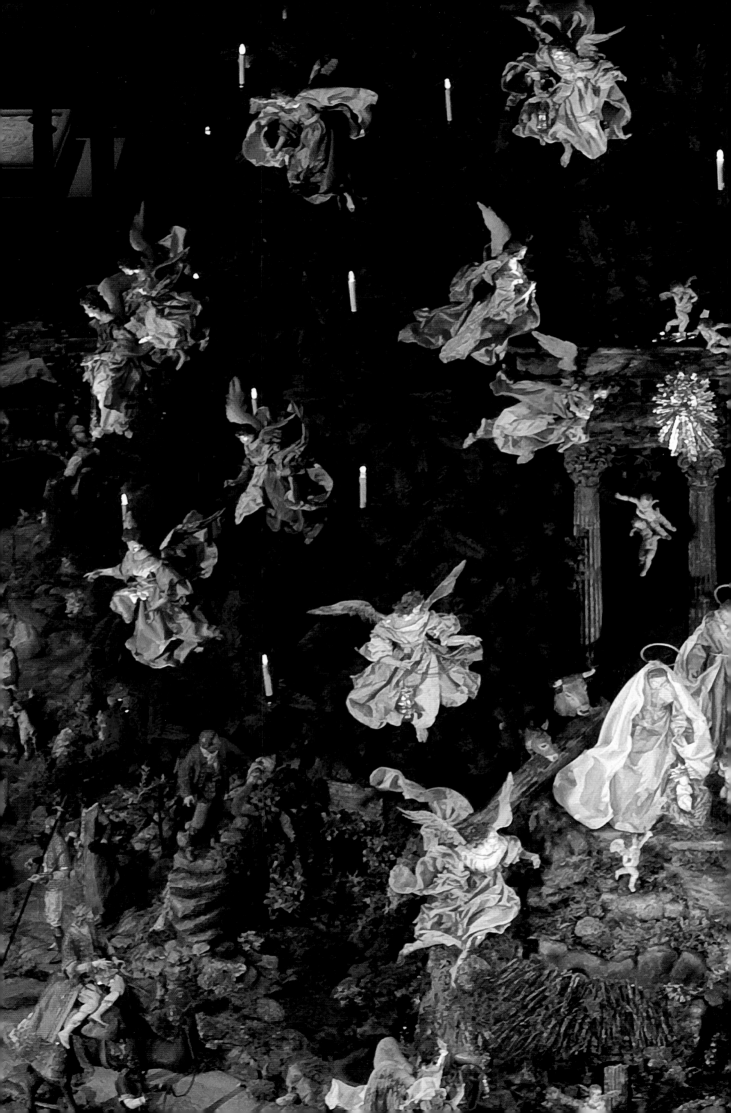